BIRDS

BIRDS

The Paintings of

TERANCE JAMES BOND

ATHENA PRESS, INC.

NEW YORK / TORONTO

First published in the United States in 1989 by
Athena Press, Inc.
386 Park Avenue South, Suite 500
New York, NY 10016

Distributed in Canada by
Athena Press
PO Box 267
Mississauga, Ontario
L5M 2B8, Canada

0-922884-00-5

Library of Congress 88-083640

This edition published by kind permission of
Lutterworth Press, PO Box 60, Cambridge CB1 2NT, England

Printed in Italy

Contents

Introduction

It seems only a few months ago since I was standing, rather nervously, in the Haste Gallery in Ipswich waiting for the doors to open on my first exhibition of bird paintings. It was a momentous day. The exhibition was successful; all the paintings were sold on the first evening and my career as an artist was launched. This, in fact, happened almost twenty years ago.

I had given up a secure career as a Design Engineer and was determined to succeed in making a living as a wildlife artist. It was the combination of this determination together with the unceasing support of my wife Jill, many friends, and a local gallery, that has led to my success. Now, for the first time, some of my paintings have been collated in a book.

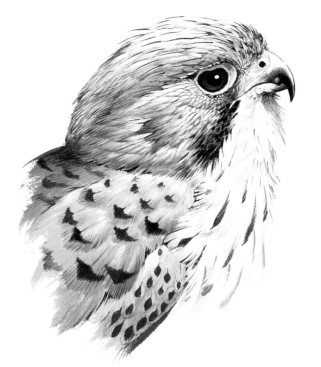

A number of points are immediately apparent when examining the paintings from the earlier period of my career. Obviously, I had much to learn about the composition of a successful painting, but concentration on detail was of great importance to me from the beginning. It is also interesting that the subjects of my work have not altered over the years. A love and fascination for all things natural has always stimulated me to paint. Although my technique has improved, all my paintings today remain highly detailed studies of birds in their natural surroundings, portrayed in as realistic a style, as they were then.

Many artists create an impression of their subject with a wash of colour and a hint of line. This is an approach I have avoided because I see my work as an exploration and celebration of the natural world. Unless I am able to show the viewer the closest possible representation of the bird and its habitat, I feel I have failed. It is for this reason that I paint all my subjects life-size.

To achieve the degree of detail that I feel is necessary, I use a variety of references. Of course, there is no substitute for seeing a bird in its natural habitat, but time and circumstances often make field work difficult. I, therefore, have to make use of various *aide memoires*. I often sketch details which attract me or note subjects which may be of use in a future painting. I also photograph both birds and their habitats in colour and black and white if I am unable to sketch them. When working on a painting in the studio, I use these photographs and sketches for reference. I also have a large collection of skins which I use to check details of size and feather patterning. I am fortunate, too, to have access to the collection of skins at the Natural History Museum.

By using a variety of reference material I feel I am able to create, not only a precise and accurate picture of the bird itself but also to suggest to the viewer the

exhilaration and awe of seeing these beautiful creatures in their natural surroundings.

Once in a while I will throw all the paraphernalia an artist carries with him, together with a camera, into the back of my car and drive from my home in East Anglia to Scotland. I love Scotland. The scenery and wildlife there are in complete contrast to those of my home and I find them extremely refreshing. Whenever I walk in unfamiliar countryside, I feel I am certain to see something unusual, which no one else has noticed. Presumably this is a result of all the mountains, lochs and burns, which stimulate me to see things in a different way. When I return to the studio after such field trips, I process all the films I have taken, and then print those which will be used with the sketches to form the detail or complete structures for new paintings.

Many people who like to draw or paint find that particular objects, for instance stones, are capable of making so strong an impression upon them that, unless they can sit down and try to capture in pen or paint what they have seen, there is a genuine sense of loss. It is a challenge, I suppose, from nature and explains why one feels so intense a satisfaction when a drawing works first time. Sometimes, of course, it doesn't, and it is this challenge which confronts the artist every time he sees something which moves him and re-awakens the need to commit those emotions on paper. It remains impossible, of course, to paint a smell or a sound, although it is so often those elements which contribute most towards the memory of a particular scene.

As a self-taught painter, apart from some enjoyable and memorable art lessons at school, I have never received a formal art training. I paint for two reasons. In the first instance for myself, and secondly from a total love of all things natural and the sheer pleasure I get from birds and their natural habitat.

All the paintings in this book are executed in gouache, a water colour medium which I found to be very versatile. During my early years I chose to paint in oils mainly because it seemed to be the medium which artists through the ages had used for their major works. After a short time, I decided that this medium was not for me. With gouache I found I had all the richness and flexibility I sought. I have used this medium for nearly twenty years and have yet to discover its limitations. I find that it enables me to create effects that I had thought to be impossible.

Many of the backgrounds for my paintings, take weeks to paint. A piece of ancient tree trunk, festooned with lichen, full of cracks and chewed by countless generations of insects, presents such a challenge. It may be only after the preliminary drawings are finished that I can give any thought as to which species of bird or birds will share the canvas with that piece of wood.

Some birds are, however, of such inherent beauty and possess such a dynamic quality that they do not require a complex background. My first sight of peregrine falcons at close quarters was a stunning experience. The birds exuded such power and strength and yet at the same time possessed a gentleness which appeared contrary to their nature. In attempting to capture this image I have to convey not only an accurate visual description of the birds, but also the sense of excitement and privilege I feel from having had so intimate a contact with them.

Anyone looking through this book will notice that trees of every kind have a fascination for me. We are fortunate to have a few acres of land around our bungalow, and here I have attempted to encourage as wide a variety of flora and fauna as possible by careful and selective planting. Trees were the first consideration and over two hundred hardwood and softwood varieties have been planted during the last ten years.

The south-east of England suffered one of the worst gales for hundreds of years in the autumn of 1987. During six hours, an estimated fifteen million trees were uprooted, blown down, or smashed to pieces. Our gardens and meadows were devastated. It was immensely distressing to lose trees which had been so carefully planted but particularly tragic to lose several mature trees, some more than a hundred years old. The trees looked colossal lying on the ground, revealing branches previously out of reach and out of sight.

Many of the larger branches and trunks of these trees have been left where they fell. Some landowners have cleared away the "mess" of fallen trees on their land. If it is possible, however, to leave a fallen tree *in*

situ, it becomes an instant nature reserve. In the natural order of things, once a living structure has died or succumbed to disease, there are a whole range of plants and animals that specialise in the breakdown of matter, and within a few years a dead tree will support countless insects, larvae and fungi, all feasting away at this organic "picnic table". Birds, like woodpeckers, are inevitably attracted to such areas. The smaller species too, such as robins, warblers and wrens will nest, feed and seek shelter in the large sections of dead and decaying timber.

Although this is a book about birds, we will only be able to encourage them by providing suitable habitats. Trees provide an essential habitat for wildlife, and the deciduous woodland is, in fact, one of the richest and most rewarding environments available. Those who take time to stand in a large and mature wood on a still autumn day to watch and listen to the animals and birds going about their daily activities, against a backdrop of gold and red-tinted leaves and ripening wild berries, will understand. If I can impart some of this feeling and emotion to others, through my paintings, then I feel that painting a picture is wholly worthwhile.

TJB
Kersey, Suffolk,
1988

Robin

Ask almost everybody in the United Kingdom which of all our resident birds they would consider to be their favourite and the answer will be the same. A survey carried out in 1961 by the International Council for Bird Protection, after long deliberation and much correspondence in the national press, finally elected the Robin as Britain's national bird.

The Robin, originally a woodland species, can be found throughout the British Isles with the exception of a few of the northern isles and bleak moorland areas. It is, therefore, a bird with which everyone is familiar.

Robins are trusting birds; a resident garden Robin can become extremely tame. Encouraged and regularly rewarded with titbits, it may approach within a few feet and occasionally even become so bold as to accept food from the hand.

Robins, once established in a territory are very defensive attacking even other robins which intrude. Part of the Robin's armoury is its song. In order to maintain a particular territory the bird will sing during most months of the year, warning others of its presence and prior ownership of that area. The song is at its most sophisticated and definitive during the breeding season.

Nest building is usually undertaken by the female and the position and type of nest location are extremely varied. Holes in trees, stumps or banks, behind creepers on walls, old tins, kettles, garden equipment and derelict cars may all be used. Building material is basically a bulky collection of dry leaves and grasses, with occasionally a lining inside of moss and a few feathers. Clutches usually number four or five eggs and the first brood can be under way by late March, a second brood is normal and a third possible.

Although the Robin epitomises Christmas, appearing on cards and wrapping-paper each year, it is, in fact, quite vulnerable to prolonged bouts of cold weather and will quickly succumb if unable to gain safe shelter and ample food.

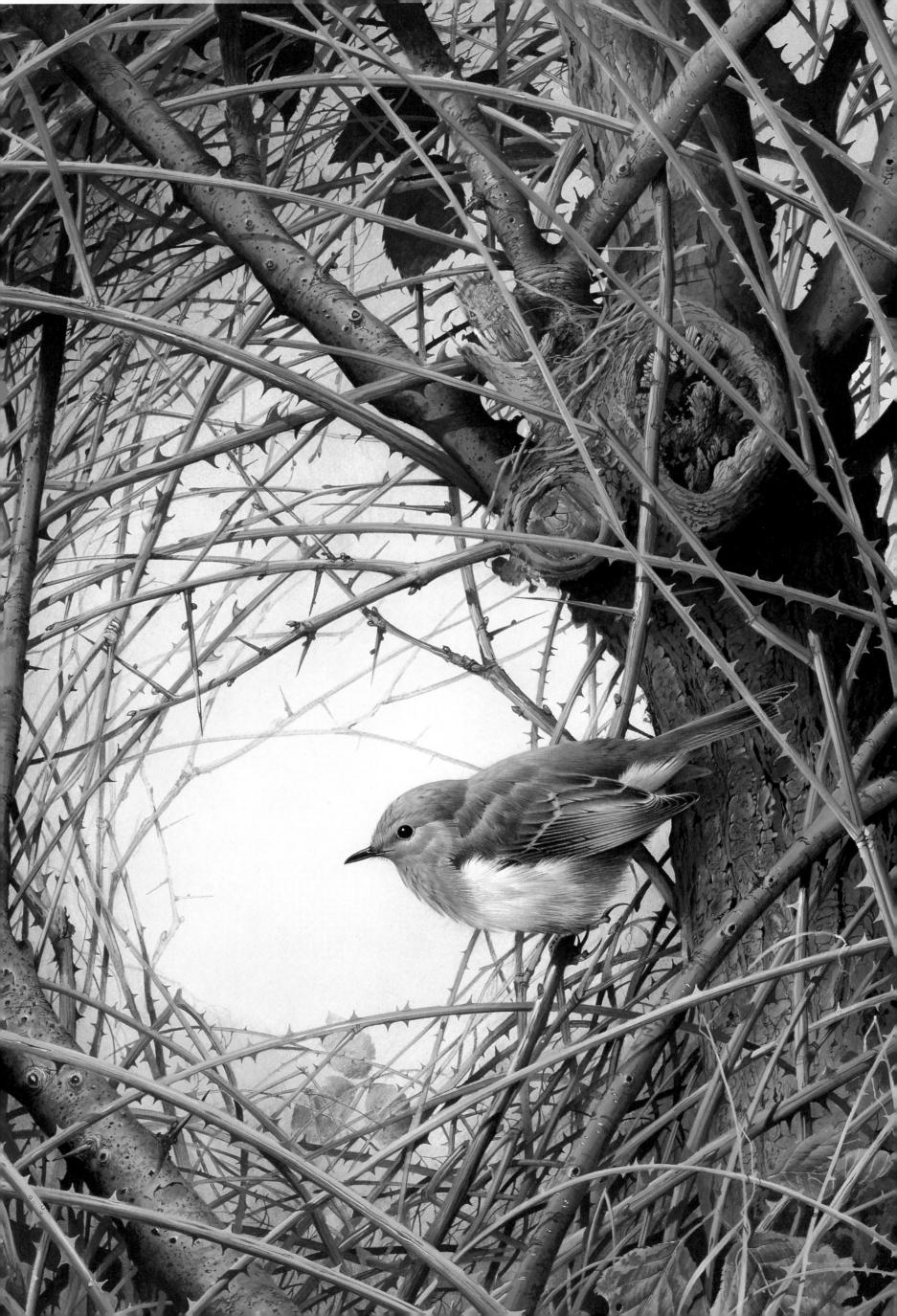

Finches (Brambling, Goldfinch and Greenfinch) and Yellowhammer

The worldwide group of small birds that are listed under the name finches all have one thing in common and that is seeds in one form or another are a very significant part of the bird's diet. The general appearance of the various finches is very similar. Any major differences, especially in bill structure, usually reflect specialised feeding habits. The four birds shown opposite illustrate the widely differing colouring and to a lesser extent the various types of bill structure found in the family group.

The Brambling *(top left)* is a close relation of the Chaffinch and both of these birds are classified under the heading *Fringillinae*, a sub-family containing birds not too specialised in their feeding habits which, whilst eating many seeds, will also readily consume insects. The two other finches illustrated are of the sub-family *Cardulinae* and are all much more grain and fruit oriented. They even feed their young on pre-digested seeds supplemented with the occasional insect.

The Goldfinch *(top right)* is a widespread species and its fondness for the flowering heads of thistles and other wild plants is well known. Its beak is therefore quite long and pointed, enabling the bird to probe deeper into the flower head. The Greenfinch *(bottom right)*, however, has a sturdier bill and its appearance is somewhat more robust than the Goldfinch's. Not surprisingly the bird's diet contains some of the larger and tougher seeds. The bird will feed in trees, particularly elm, mature hedgerows and gardens. A variety of weed seeds are also taken direct from the plant or the ground.

The Yellowhammer *(bottom left)* is more rural than urban and even in the coldest weather the bird remains an unusual garden visitor. In its preferred environment, however, the Yellowhammer is not uncommon, having a population of around 1,000,000 pairs. During warm spring and summer evenings, the cock bird will perch on a conspicuous twig above a hedge and repeat a rather monotonous but instantly recognisable song for anything up to an hour.

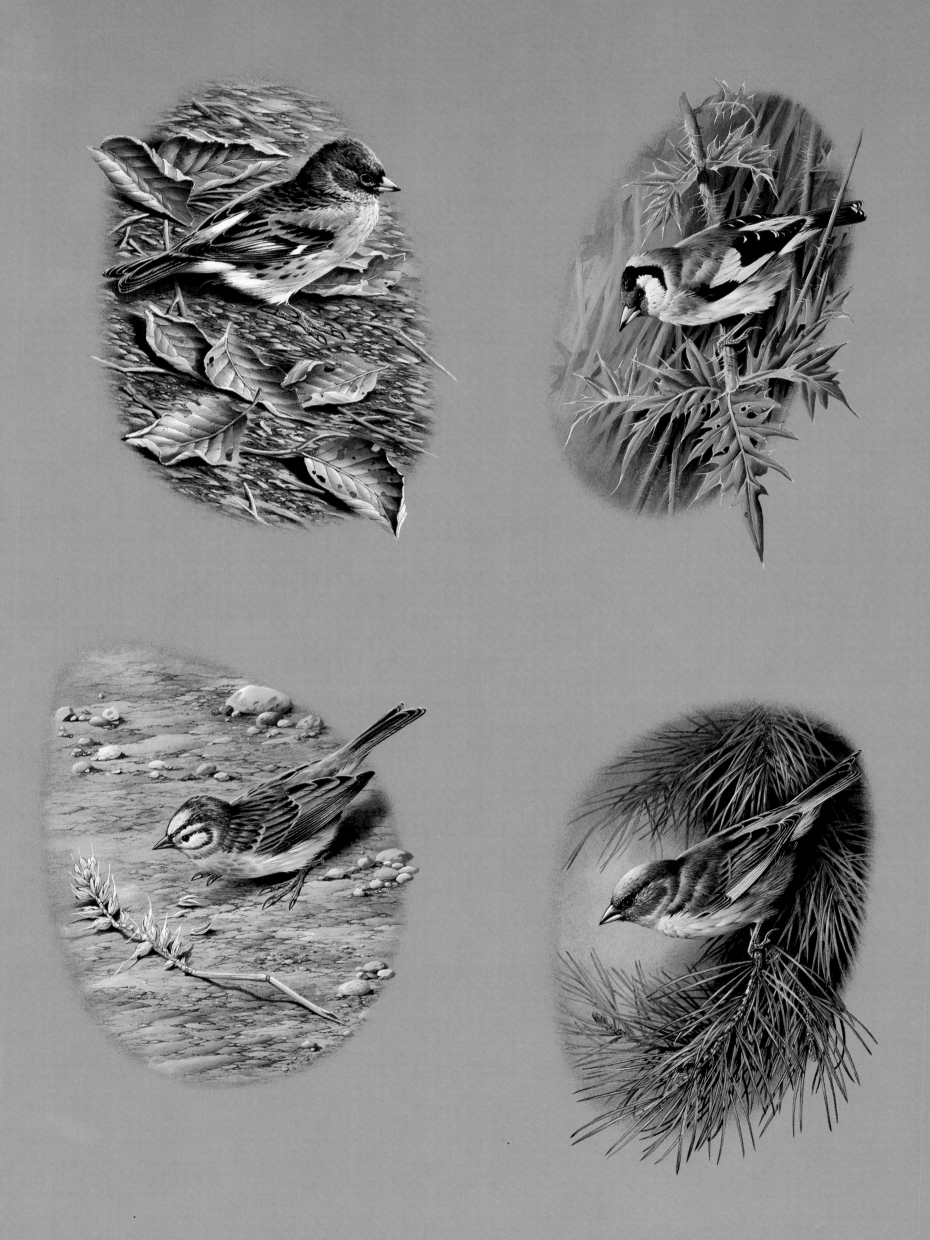

Blackbird

Everybody is familiar with this member of the thrush family, mainly because of the bird's successful adaptation to the urban environment. Primarily a woodland species, the Blackbird has managed to establish itself as a breeding bird of parkland and gardens, and has become dependent to a great extent on lawns, playing-fields and ornamental shrubs for its two main foods, worms and fruit.

Because of this successful adaptation to a wide variety of habitats, the Blackbird is now probably the most numerous species in the British Isles, our own resident population being increased by over-wintering visitors from Scandinavia.

The bird is a bold and aggressive species and will behave in a very territorial manner towards other members of the thrush family. In terms of population levels and behaviour, it completely dominates its well-known relation, the Song Thrush; even immature and first year Blackbirds will bully and intimidate mature Song Thrushes in order to steal food.

The Blackbird's nest is a very well constructed affair, consisting of small twigs and grasses woven to form a robust, deeply hollowed cup, the inside of which is lined with a mixture of dead leaves and mud, moulded into shape by the female, and finished off with a lining of soft grass. It is so well constructed that up to three broods may be raised successfully in the same nest and it has even been recorded that nests from previous years are refurbished and used again. As one would expect from such a cosmopolitan species the nest can be located practically anywhere, ranging from more natural sites such as hedges and shrubs, to sites as diverse as the interior of buildings, old cars, farm machinery and even aircraft.

The painting opposite depicts a cock bird in woodland rather than an urban environment, but just to reinforce slightly the connection between man and this particular member of the thrush family, I have shown evidence of urbanisation by means of the silhouetted gate in the background. In order to keep the overall pigment range I have chosen a setting of hedge maple leaves that are linked by their autumn yellow to the Blackbird's only concession to colour – its beak and eye ring.

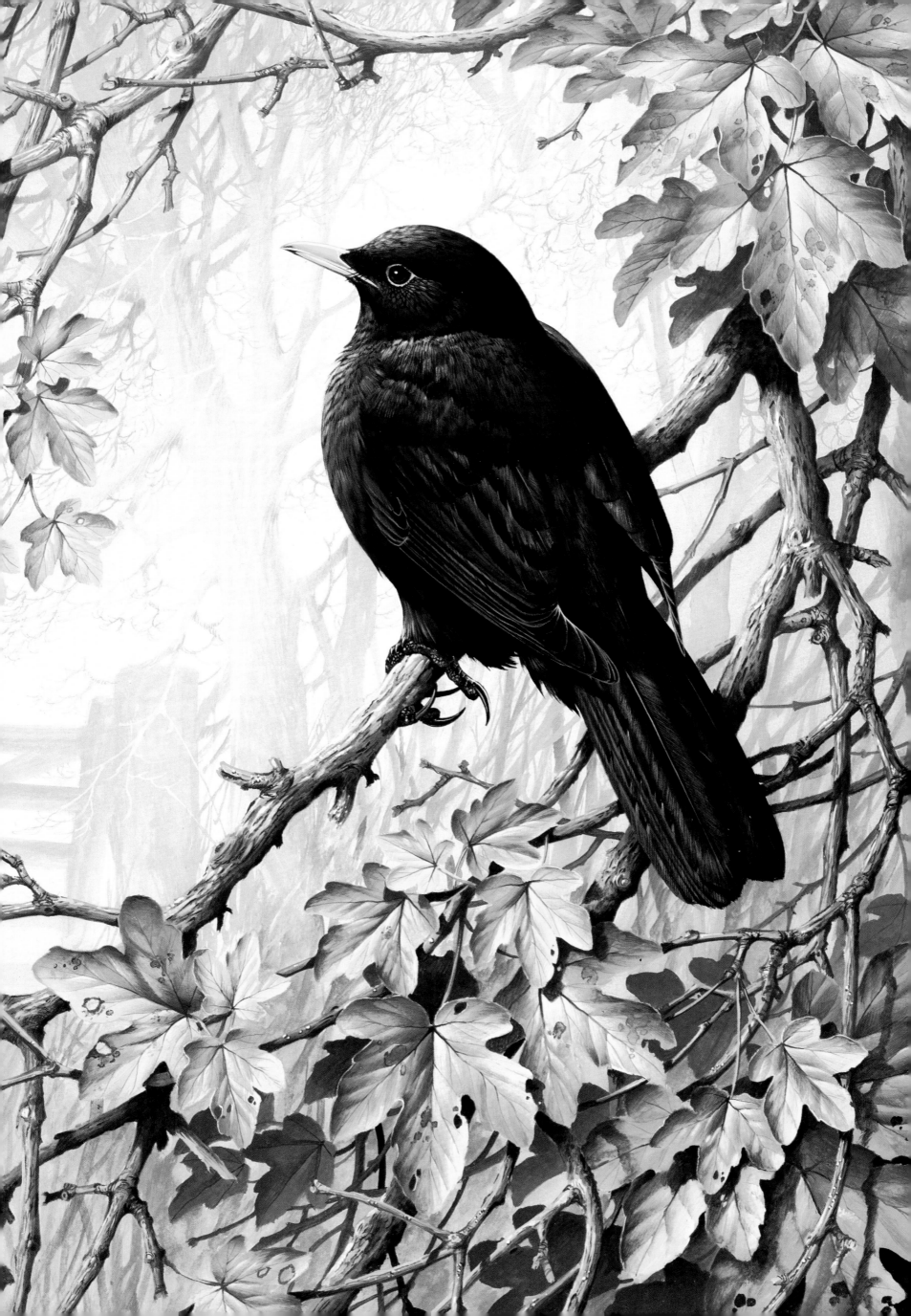

Song Thrush

It was the second week in February and unusually mild. In fact it seemed particularly warm, but this was really only an illusion brought about by the fact that we had just had one of the coldest Januarys on record. I live in a part of Great Britain known as East Anglia (only some twenty miles from the North Sea) and it is usual to have a bitterly cold January practically every year! As I walked through my meadow during that softer and milder week, two things became refreshingly obvious. Firstly the ground, grass and trees had a distinct smell about them. It is easy to overlook the fact that during really cold weather there are very few scents, but on this day it was beginning to smell almost spring-like. The second and most reassuring thing was the sound of a male Song Thrush singing his heart out at the top of a dead elm. After the relative quiet of winter it was lovely to hear this familiar bird getting to grips with the business of spring. The thrush was not singing just for my benefit, the prime reasons for this outpouring of melody were to establish his territory and to attract a mate. Usually the Mistle Thrush is the first real songster of early spring, but for some reason that year his smaller cousin had beaten him to it.

Song Thrushes are early nesters and one March I can remember seeing a bird sitting on eggs whilst the surrounding countryside was enveloped in the aftermath of a snowstorm on the previous day. The bitterly cold weather continued for several days and this clutch really stood no chance. A week later the nest had been deserted and the four eggs lay now stone cold in the bottom of the mud-lined cup.

In general appearance the Song Thrush is a smaller bird than the Blackbird and has a warmer colour to its plumage than the Mistle Thrush. There is a distinct orange-yellow to the bird's flank which makes it appear to be lit by sunshine even on a grey day. I have deliberately kept the painting opposite fairly simple in construction and colour in order to show off the subtle shades of ochre and umber in the bird's plumage. The pale blue-grey sky helps to keep the silver birch looking cool and reinforces the warmth of the thrush.

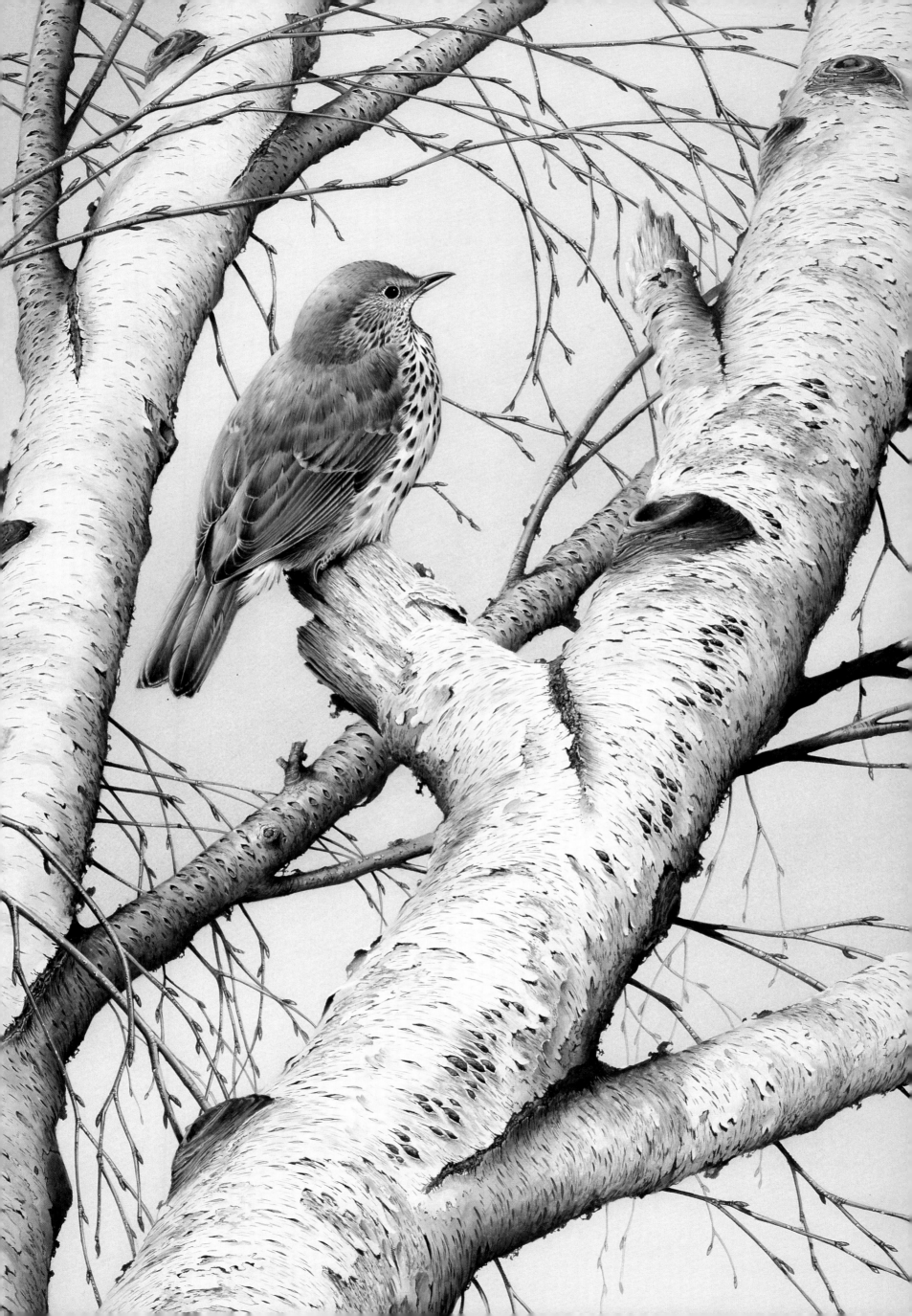

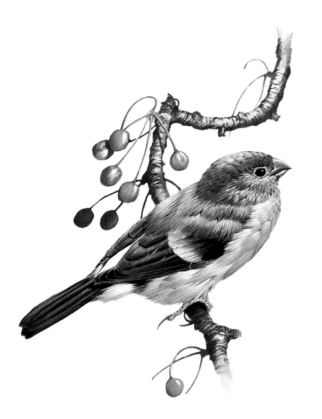

Bullfinch

Bullfinches and fruit trees do not mix, or rather they do, and that is the problem. This most brilliantly coloured of all the finches would seem to have everything going for it in the popularity stakes if it were not for its one unfortunate habit. After all the bird is beautiful, nobody can deny that, the cock more so than the hen admittedly, but in her own understated way she too is very attractive. As a species it is not too numerous, and so when it is seen, one would think that most people would be delighted. It is also a shy almost retiring bird in character, not even possessing a song that draws it to our attention. All in all not a bad little bird to have around you might think, but for many of us this is definitely not the case.

Bullfinches love buds. The name Bullfinch is probably a corruption of the words bud finch, a title apparently given to it by our Anglo-Saxon ancestors. A pair of these lovely little birds can cause havoc on a fruit tree in a very short time, and several pairs over a period of a couple of weeks can destroy the potential fruit crop of an entire orchard. Of all fruit trees it would seem that pears are their favourite, whilst currants appear to be their preferred soft fruit. The problem is an annual nightmare for fruit growers and unmitigated war is waged on these finches during the winter and early spring months. For it is at this time that the bird's natural food of seeds and berries has become depleted and protein is obtained through the consumption of dormant and emergent buds.

As a practising conservationist I really should try to preserve the bird's reputation as much as possible, but by illustrating the species in a setting of pear blossom, I would seem to be confirming the Bullfinch's regrettable behaviour.

It is the bird's appearance that is the problem. That bright pink breast of the cock is so vivid and of such an isolated pigment range, that there is very little that can be utilised as a background without a terrible clash of colour. White is the obvious choice and so is pale green, both are tints that harmonise well with pink. So in the end I chose the bird's favourite tree as the basis of the composition.

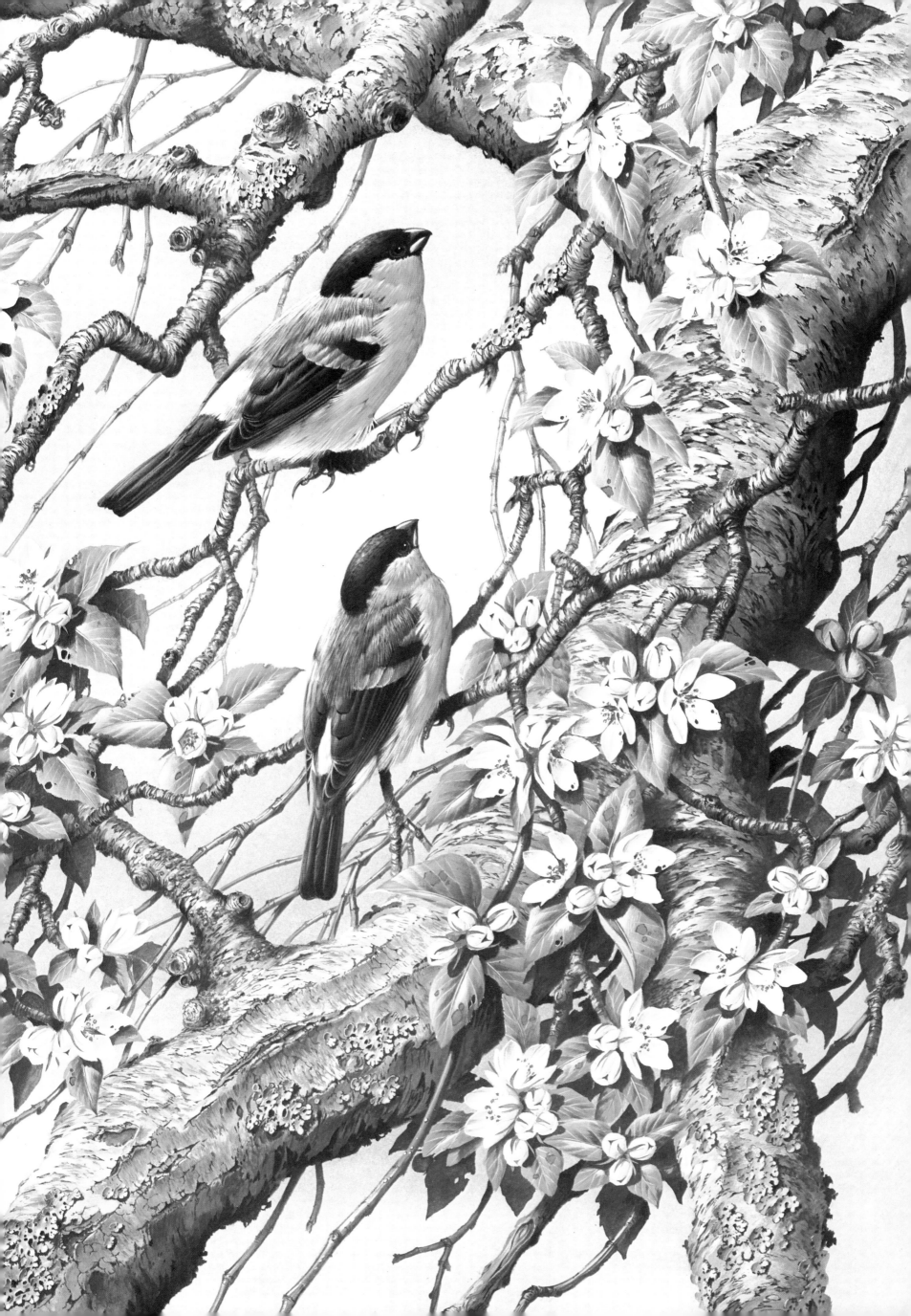

Chaffinch

A few years ago this colourful finch vied for the position of Britain's most numerous bird. However, today that place is probably held by the Blackbird. In common with a lot of the birds that regularly visit the suburban and country garden, the Chaffinch is primarily a species of hedgerow and woodland. With the ever-changing face of the English countryside the Chaffinch has for some reason not become so urbanised as many other birds.

Chaffinches were always a common sight around the buildings and stack-yard of my parents' farm, the main attraction for them being, of course, the spilt and discarded grain and various cultivated seeds that were always present. The habit of feeding in this agricultural environment is without doubt the origin of the bird's common name, Chaff-Finch. Interestingly this species' scientific name also provides a clue to another of the Chaffinch's characteristics. A literal translation of the name *Fringilla coelebs* is batchelor finch: throughout Europe during the winter, Chaffinches form large segregated flocks of predominantly one sex and congregations of females or males can be seen in different areas.

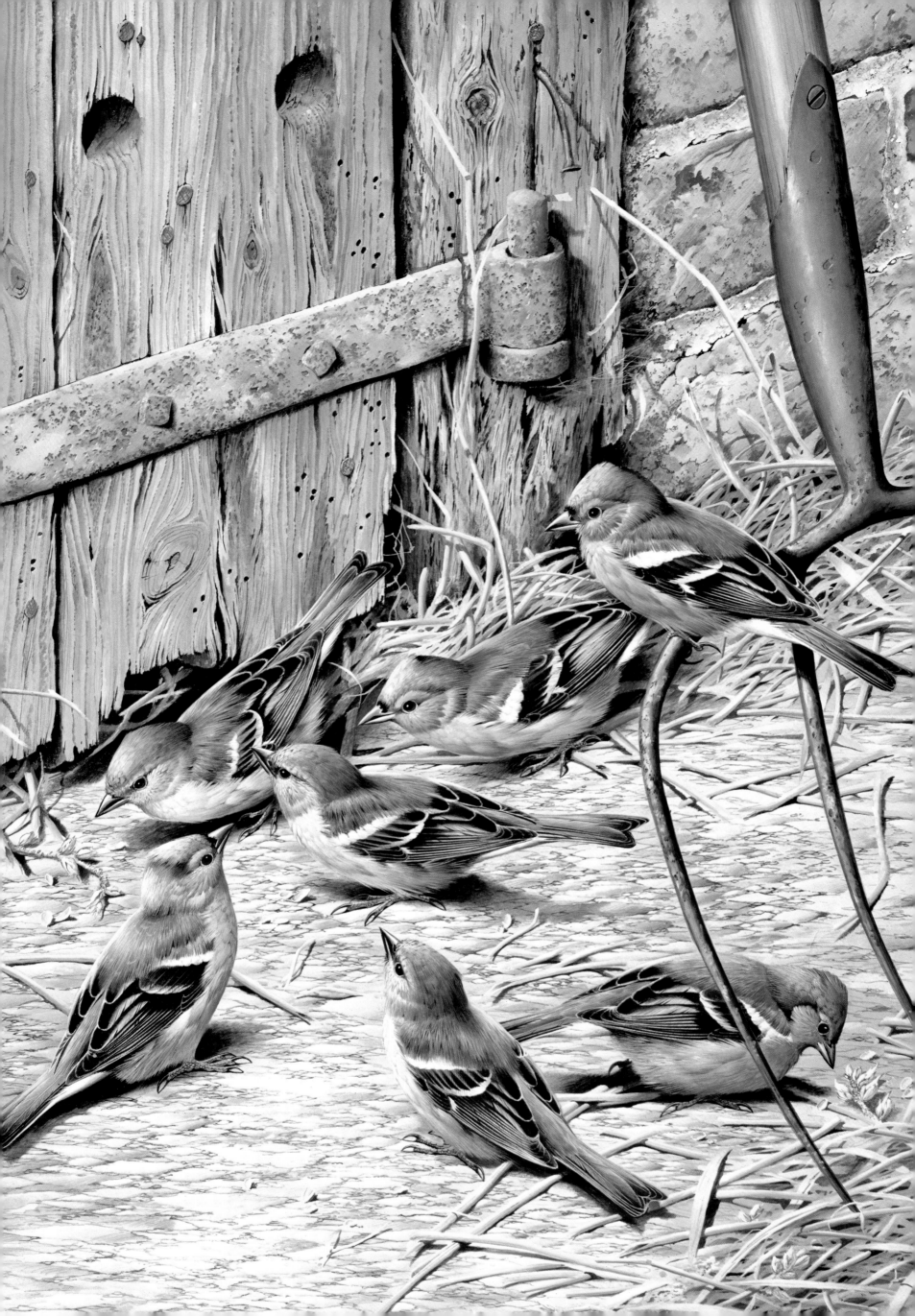

House Sparrow

All artists have their favourite colours and range of pigments that, given the opportunity, they would use as often as possible. My own particular preference is for the browns and umbers, the shades that some people would refer to as autumnal. Lots of birds are brown, or a combination of this colour and its variants, several of the owls and game birds for instance. In their case it is usually the hen, for various reasons, not least of which is to provide a degree of camouflage during the nesting season. Luckily my preferred colours occur on a bird which also happens to be a favourite subject of mine – the common House Sparrow. Undoubtedly this would surprise a number of people. It would be normal to assume that given a free choice of subject, most artists would select something a little more dramatic, or a bird with more charisma and charm, but certainly not a sparrow.

Beauty, however, is in the eye of the beholder and for me the species *Passer domesticus* whilst generally overlooked or even dismissed as a bird of no interest, actually presents the artist with enormous possibilities. The scientific name of the House Sparrow presents the proof that here is a bird that is inextricably bound up with civilised man. Apart from really inhospitable regions, such as the North and South Poles, the sparrow as a species or sub-species can be found on practically every continent. Because of this close affinity that the bird has with man and his environment, it is not surprising that if asked to name the most common bird in Britain many people would assume it to be the House Sparrow. This is not the case however, in the last nationwide census it was the Blackbird that came top of the list, followed very closely by the Chaffinch and the Wren, three species whose original habitat was woodland, but that have adapted, to a lesser or greater extent, to co-exist with man. Away from human habitation and conurbations, the House Sparrow is relatively scarce.

Nevertheless in its own particular niche there can be no doubt that the sparrow has adapted to many situations and has become a highly successful species. Nesting will take place anywhere in, on, or near buildings of any sort and, providing that sufficient food is near at hand, these enterprising little birds will raise up to three broods in a season.

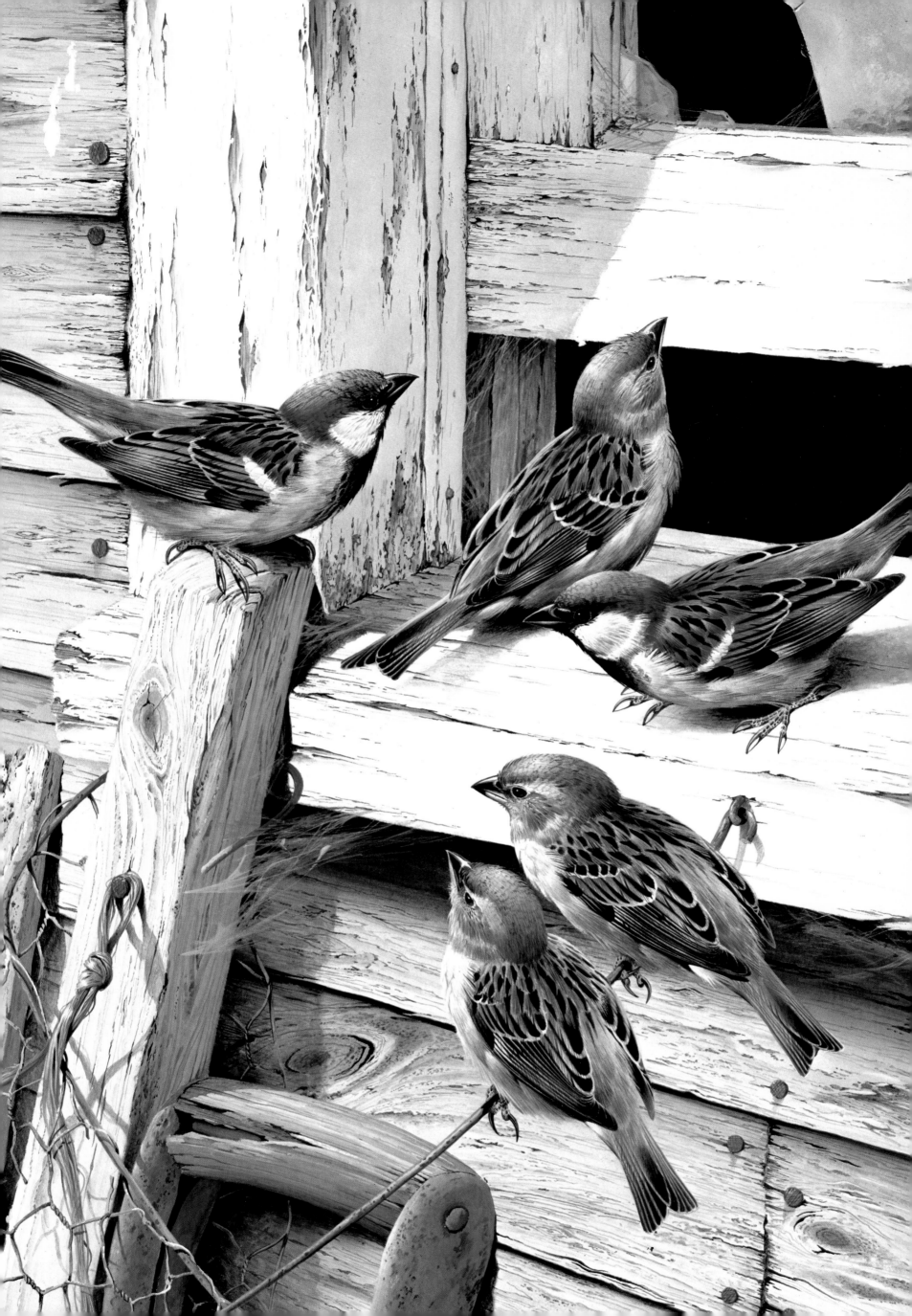

Sparrows offer practically unlimited scope for picture composition, as the environment that the species tends to inhabit contains virtually anything associated with modern man. The idea for the apples and cock sparrow painting was prompted by the sight of some old apples lying discarded outside a neighbour's garden shed. The mixture of colours and the very pleasing way the light fell onto the shiny surface of the fruit presented a challenge I could not resist. Even before the picture had reached the preliminary stage it was obvious to me which bird was needed to complete the composition.

For the painting of the five sparrows on the garden-shed window-sill I used only the range of colours that was contained in the bird's plumage; in fact this gave me quite a selection. Keeping the overall colour of the picture within these parameters prevented what is in essence quite a complex structure from becoming too fussy. Towards the end of the work, however, I relented slightly and included some red in the shape of a piece of nylon garden twine. Besides introducing a degree of relief from the monochromatic feeling of the picture, it also reinforced the fact that the sparrow is never too distant from man and his modern environment.

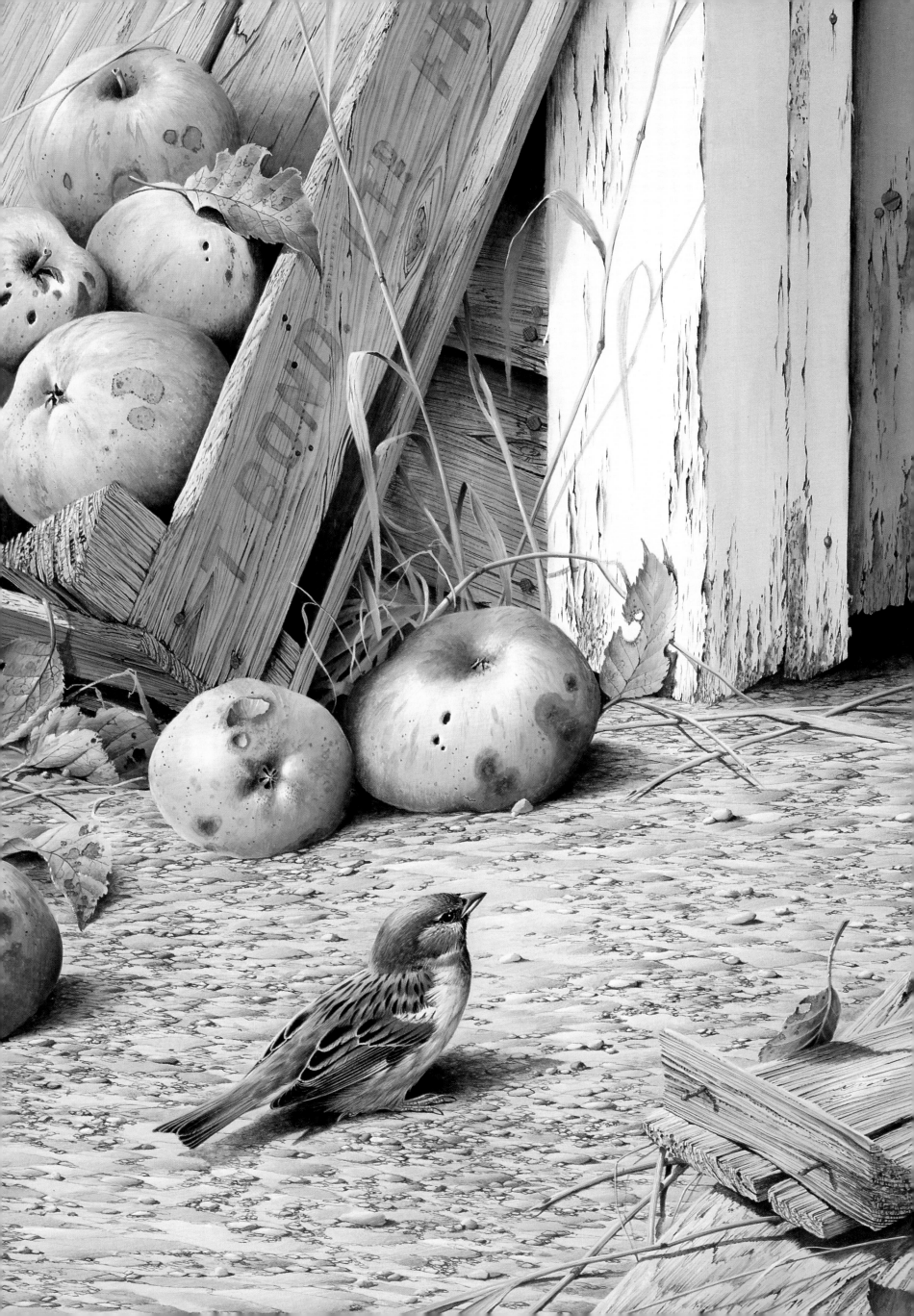

Wren

Many people in the United Kingdom think that this little bird is our smallest resident species, but it is, in fact, larger than both the Goldcrest and the Firecrest by about a quarter of an inch. However, the Wren can generally be considered as the smallest bird that most of us will encounter with any degree of frequency.

This tiny bird is remarkably adaptable, will live and nest in woodland, gardens, town or country, and is probably one of the most widespread and numerous of British species. The nest is an intriguing construction of grass, leaves and moss all woven into the shape of a dome about the size of a grapefruit, with a small hole providing entry and exit. Two broods of up to six young are raised during April and May. Some cock Wrens display the unique habit of undertaking the construction of more than one nest, not all necessarily being completed; up to five of these trial nests can be made before the hen decides to select one to her liking.

The capacity of Wrens to provide a large number of offspring each year is fortunate indeed, for, in common with many other small birds, the Wren can be severely affected by prolonged cold winters. Small birds tend to lose heat much faster than larger birds. To help alleviate the problem of excessive heat loss during cold winter nights, Wrens will resort to communal roosting, and as many as fifty birds will sleep in one large group. This in effect turns a small bird into a large one and enables them to survive the low temperatures. Ironically the bird is known as the Winter Wren in the United United States of America.

My painting opposite shows a single Wren on the top of an old nestbox, not because it represents a particular nesting location, but because it is a typical winter roosting site. The bird has been placed in the most prominent position in the picture and is immediately obvious despite the fact that it is such a small subject in a comparatively large painting. Once again I have selected only a limited range of colours to complete the work, but I felt that this was best as the overall structure of the painting is quite complex.

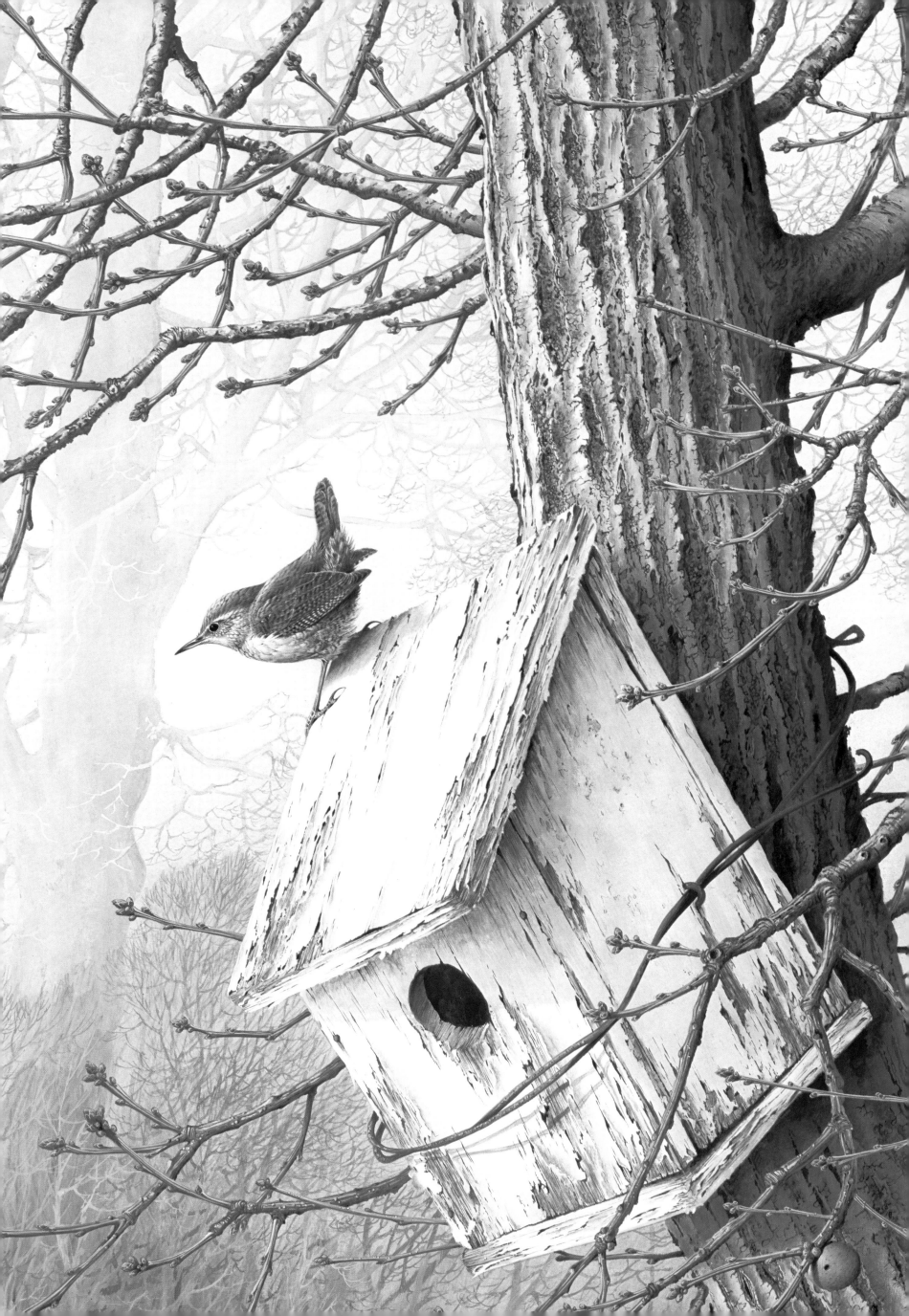

Long-Tailed Titmouse

Most people see the various members of the titmouse family during the winter and early spring when these birds are attracted to the birdtables and other garden feeding stations. Once the cold weather has passed and warmer temperatures suggest the arrival of spring, the titmice will start to drift away from the gardens where they have congregated in mixed groups and will return to their natural habitat of hedgerow and woodland. Gardens with a number of trees and mature shrubs will retain one or two pairs of the most common British species, the Blue Tit and the Great Tit, particularly if nesting boxes are provided. However, the Marsh Titmouse and the Cold Titmouse will all but disappear from gardens during the summer months.

The Long-Tailed Titmouse is certainly one of the less common visitors to the garden birdtable. The only occasion that I see these dainty little birds is when a party or small flock of them passes through my trees and taller hedges as they hunt out hibernating insects. This is a fascinating sight. At first probably only one or two of the birds are visible, but as their gentle tinkling contact call-notes are heard one becomes aware of several small birds scattered through a particular tree. As the first arrivals leave the tree the last of the flock is probably just entering from the opposite side; they work their way through the branches and smaller twigs and, continuing to maintain vocal contact with each other, eventually leave the tree and follow their companions. In this way a party of up to forty birds, permanently on the move, can drift through an area of woodland keeping in touch with each other by their musical whisperings.

The silver birch is a favourite tree of mine, not only to paint, but also to grow, and I have planted several of these trees within sight of my studio window. The colour of the trunk and the dark brown smaller twigs form an ideal foil for the titmice, with just a hint of warmth reflected from the pinkish plumage.

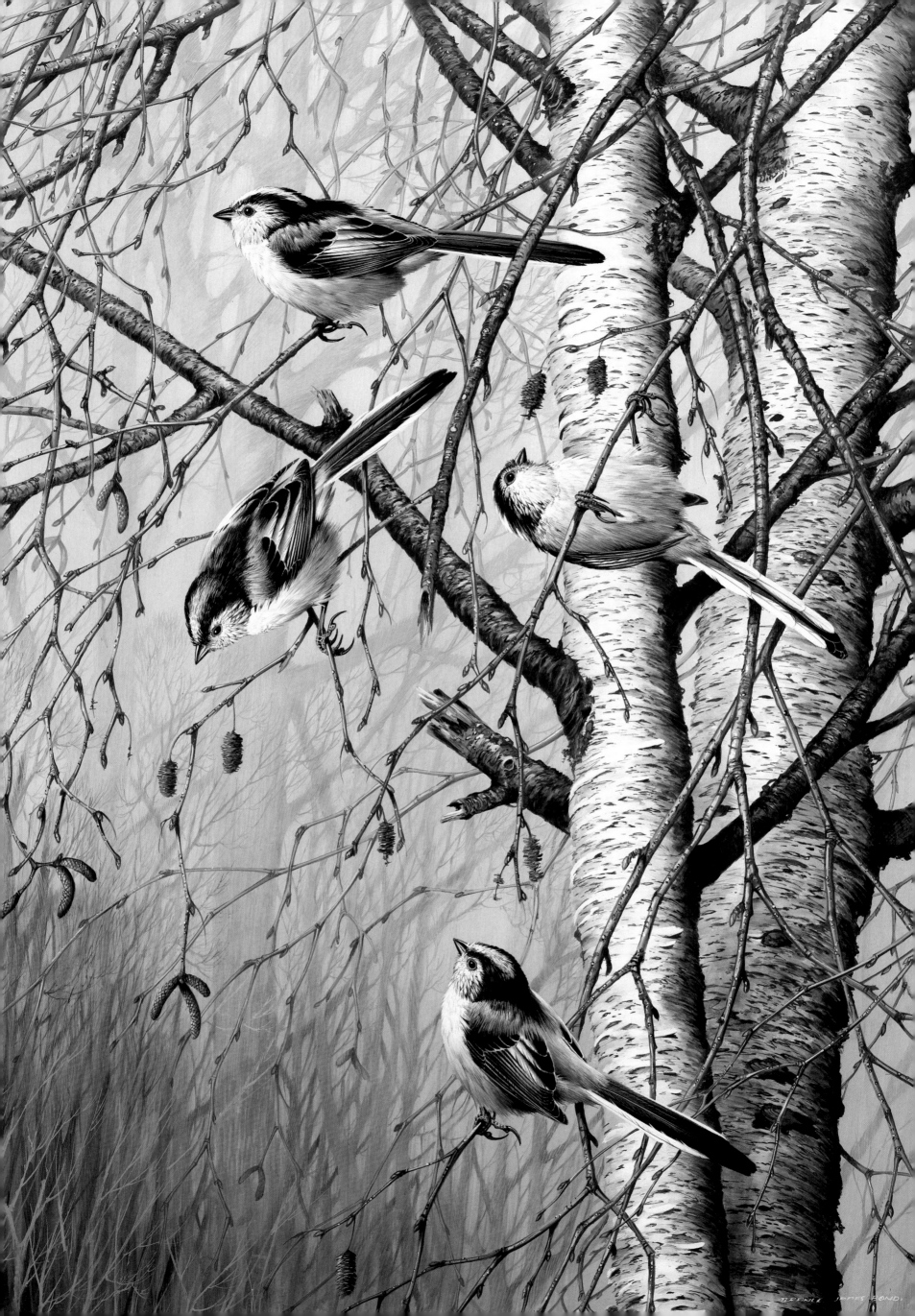

Willow Titmouse

It is practically impossible to distinguish a Willow Titmouse from its close relation the Marsh Titmouse unless you are fortunate enough actually to handle this particular member of the titmouse family. Indeed, until quite recently, the two were thought to be the same species and, without the advantage of the bird's song, it is very difficult to make a correct identification between the two in the field. Close inspection however, reveals, that the dark cap of the Willow Tit is less glossy than that of the Marsh Tit and tends towards a deep sooty brown rather than the steel blue of its companion.

My winter setting illustrates the Willow Titmouse in a woodland environment, the preferred habitat for all titmice. In such an area the bird's range will overlap with several other members of the family group, the Blue Tit, the Great Tit and the Marsh Tit.

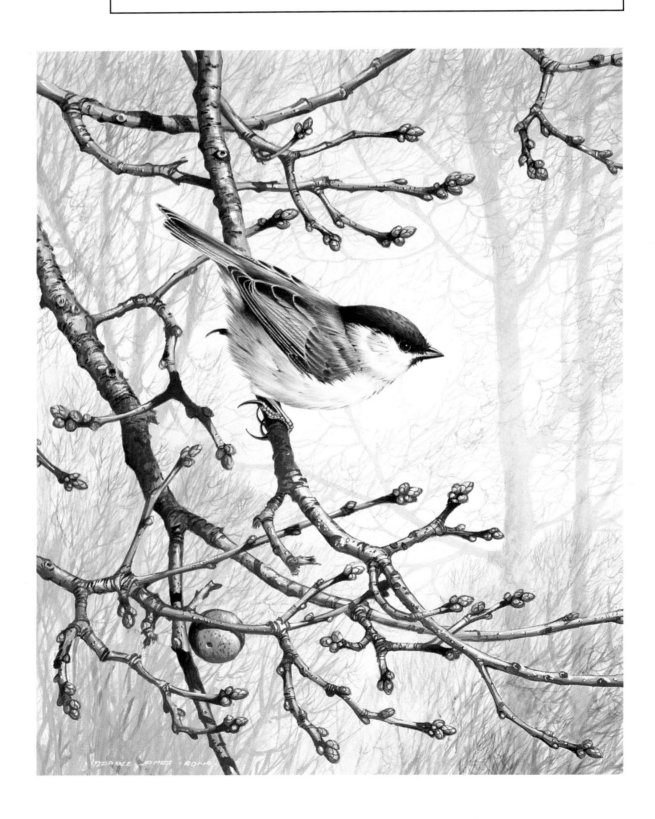

Coal Titmouse

At 110 mm long the Coal Titmouse is one of the smallest European birds. It is certainly the smallest of the titmouse family, and to my mind it is also the most attractive. Whilst the bird contains no bright colours, the greys, browns, blacks and whites are arranged in such beautiful patterns on the plumage that this species is always a pleasure to paint. This particular range of colours is set off very well by the dark greens and browns of evergreen trees (the coniferous environment being a preferred but not restricted habitat of the Coal Titmouse), so for the bird artist the colours, shapes and botanical setting are all in perfect harmony. As an adaptation to suit this preferred lifestyle, the Coal Titmouse's beak is slightly more pointed than those of its close relatives, presumably to facilitate the probing of pine and spruce needles in the search for food.

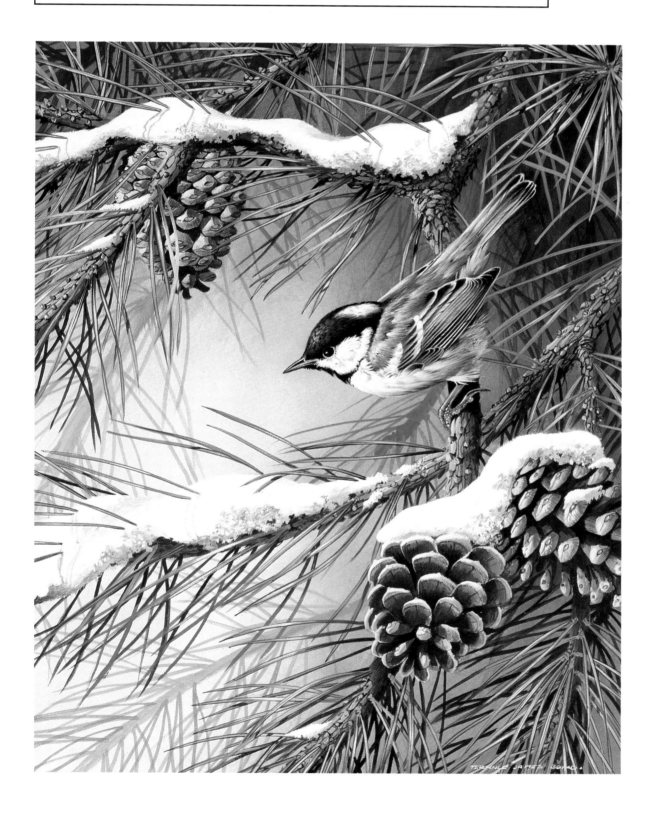

Lesser Spotted Woodpecker

Of the three species of European woodpecker resident in the British Isles, the Lesser Spotted Woodpecker is the smallest. It is also the least heard and the least often seen. Less common or widespread than the other two woodpeckers in Britain it tends to be more local in distribution. The word lesser in the name is not a derogative term, nor is it anything to do with the number of spots on the plumage; it just describes a species that is smaller in stature than a close relative of the same family, in this case the Great Spotted Woodpecker. The description in this instance is most apt, since the Lesser Spotted Woodpecker is tiny, only slightly larger than a sparrow, and so can very easily be overlooked.

When I started to plant trees in my garden and adjoining meadow some ten years ago, I did not realise how quickly this would bring rewards. By its very nature the formation of a natural environment by planting trees is bound to be a relatively long-term enterprise. While it is satisfying to watch the young trees gradually mature, one does not expect a great deal of impact to be made on the local fauna for some years. However, all the saplings were supported with pine and chestnut stakes and after the first winter the remaining bark on these started to crack and fall away. For the following two or three years a pair of Lesser Spotted Woodpeckers brought their fledged young into the garden to feed on the insects and grubs that had secreted themselves behind the fragments of bark. As the parent birds flew from one stake to another, the youngsters would follow, fluttering and begging for food. I felt privileged to witness this, because normally this species spends most of its time high up in the canopy of mature trees, where it can be frustratingly difficult, if not impossible, to see them. Not surprisingly for such a small bird, the nest hole is proportionately tiny, not much bigger than the nest hole of some of the titmice. The aperture is hollowed out by the birds and within is raised one brood of between four and six young.

I have remarked in other places in this book how pleasing black and white birds are to paint and most colour combinations will work with these two pigments. Green works particularly well and it was for this reason that I chose to show the two birds in a setting of summer maple leaves.

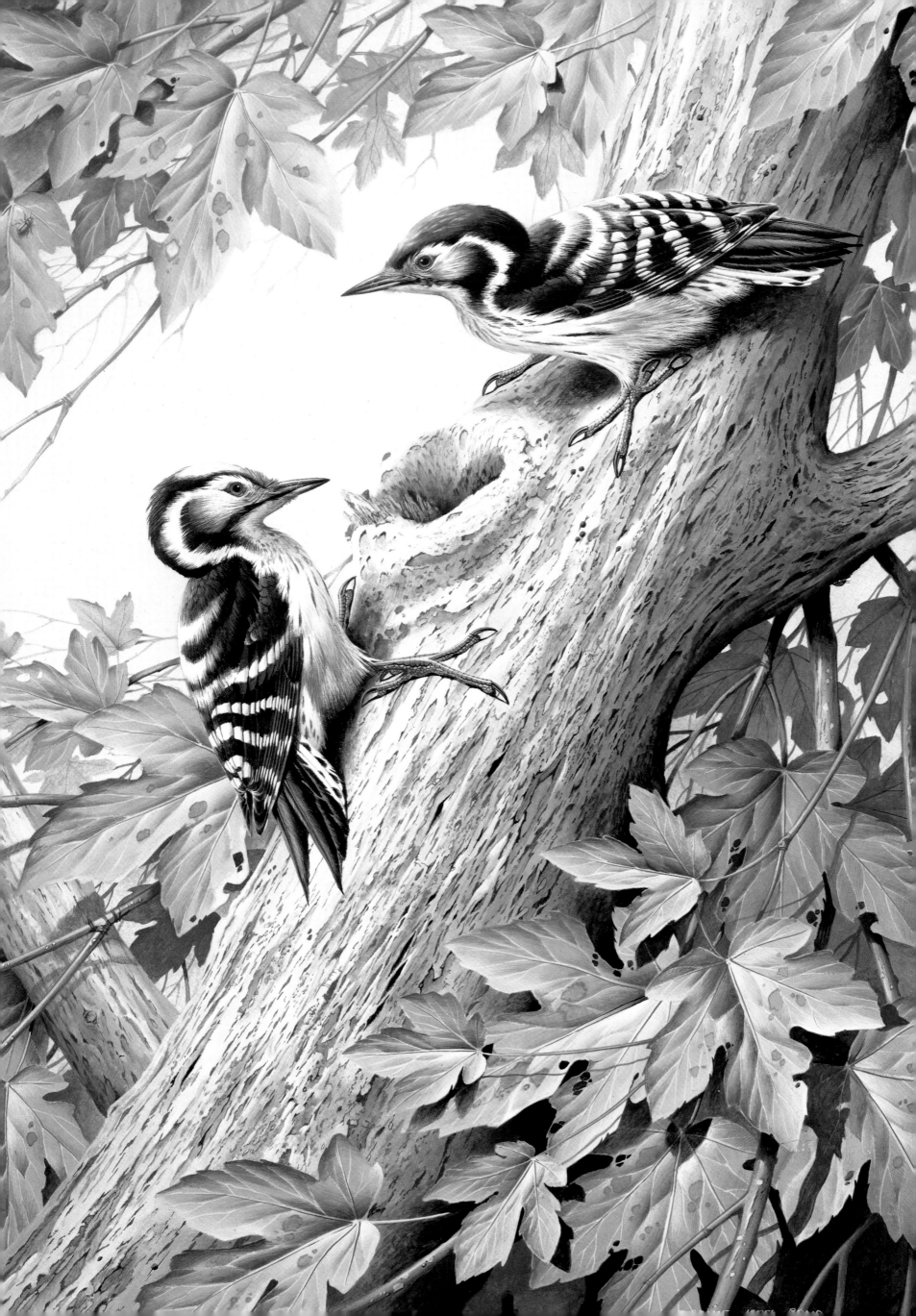

Great Spotted Woodpecker

Some twenty-five metres from my studio window grow two mature weeping willows. From one of the lower branches hangs a feeding table that I keep stocked with a variety of food during the winter months. Over the period that this table has been open for business, now nearly ten years, I can list a wide range of birds that have visited at varying frequencies in order to feed. One particular species that is known to feed regularly at such places is the Great Spotted Woodpecker. Several of my friends and acquaintances often report that this handsome woodland bird takes food from their tables quite regularly. Not so on my birdtable! The contents of the table are as varied as one could wish – a mixture of seeds, fats, fruit and nuts. I do not know why but the woodpeckers seem uninterested.

During a particular bitterly cold winter when Britain was in the grip of unrelenting sub-zero temperatures, the birds (and animals) came to depend on offerings and hand-outs that were to be found on birdtables or just thrown out on the ground. I even had representatives of the very shy members of the crow family taking food from within ten metres of my window. Then on one clear, crisp afternoon there he was, a beautiful black, white and red woodpecker on the willow trunk adjacent to the table. At last! It must be the cold weather, I thought, that had finally forced one of our resident local males to drop in for a snack! Incredible as it may seem, however, the bird ignored the food I had put out and proceeded to search the cracks and crevices of the willow-tree bark. Even in such conditions he preferred to hunt for his natural food of dormant grubs and insects instead of taking the easy way out, along with the rest of the local bird population.

Watching this dramatically coloured bird on this cold sunny day was a visual feast, and when he turned to the light side of the tree trunk the colours of his plumage against the blue sky were a lovely sight. That image stayed with me for several weeks and when the opportunity arose I recalled that January afternoon in the painting opposite.

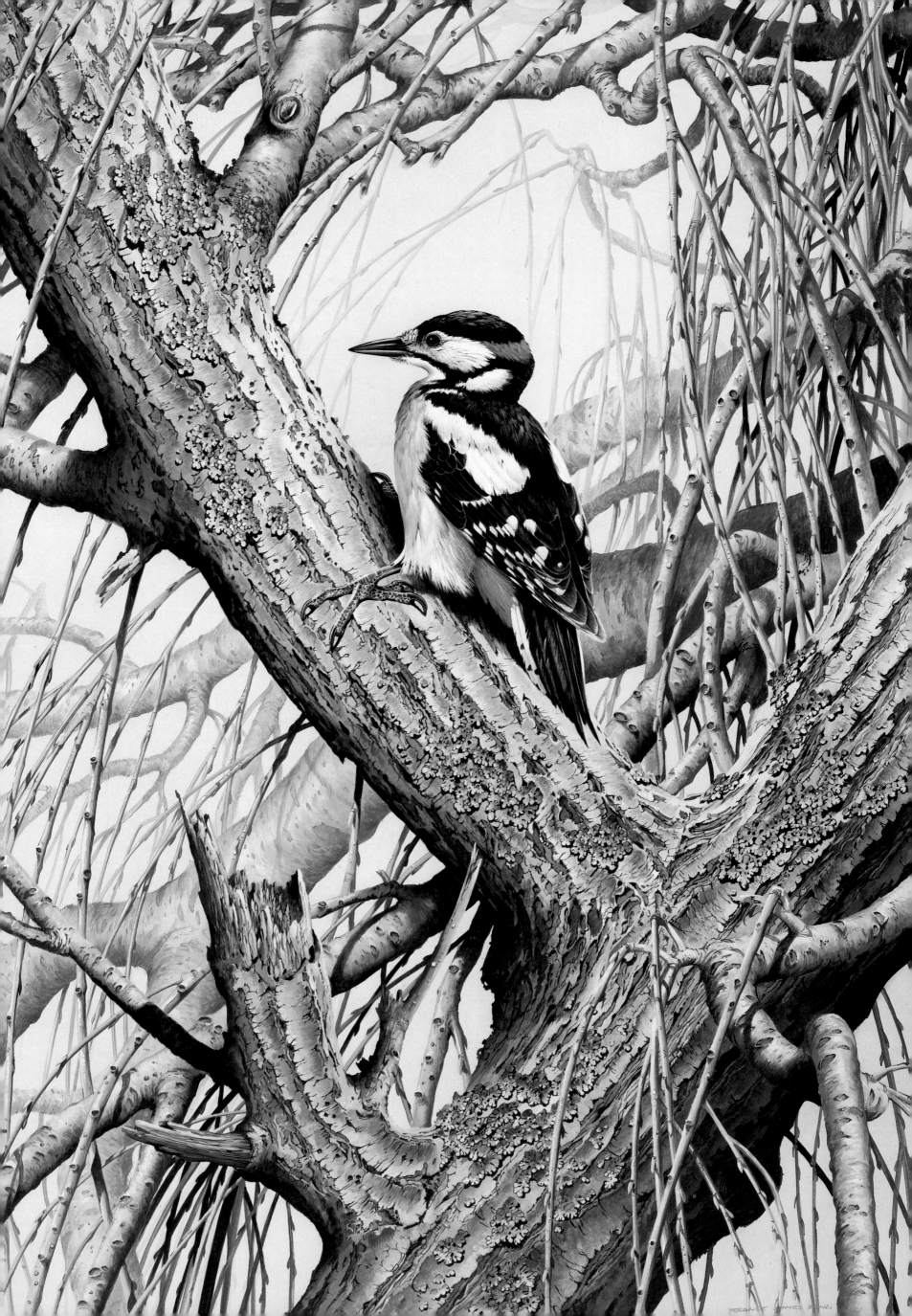

Green Woodpecker

This is the largest of the three woodpeckers that are resident in the British Isles and in my humble opinion the most handsome. From the illustrator's point of view the woodpeckers are particularly pleasing birds to draw and paint. Why? Well, just look at the shape! The bird has evolved a certain lifestyle and as a result it is engineered to an almost perfect design from beak to tail. The most obvious features of all the woodpeckers are the highly developed beak and the disproportionately large head. This is the bird's hammer and chisel. Using powerful feet to hang from practically any position, a woodpecker can wreak havoc and damage, which has to be seen to be believed, to living and dead wood alike. This avian carpenter uses a combination of head, feet and beak to hunt for food under the bark of trees and also to excavate a nest hole and chamber in which to raise a family.

One of the least characteristic aspects of the bird's behaviour is its readiness to hunt for insects, particularly ants, on the ground. Yet Green Woodpeckers are regular visitors to my lawns and I have to admit the sight of these birds hopping across the ground amidst the company of Blackbirds and Song Thrushes is rather odd.

The colours in my illustration have been kept within a range of greens and browns, in order to make a visual feature of the only other colours in the painting, the red and black on the bird's head. Scots pine was chosen as a background because I thought the shape of the needles echoed the dominant shape of the woodpecker's beak.

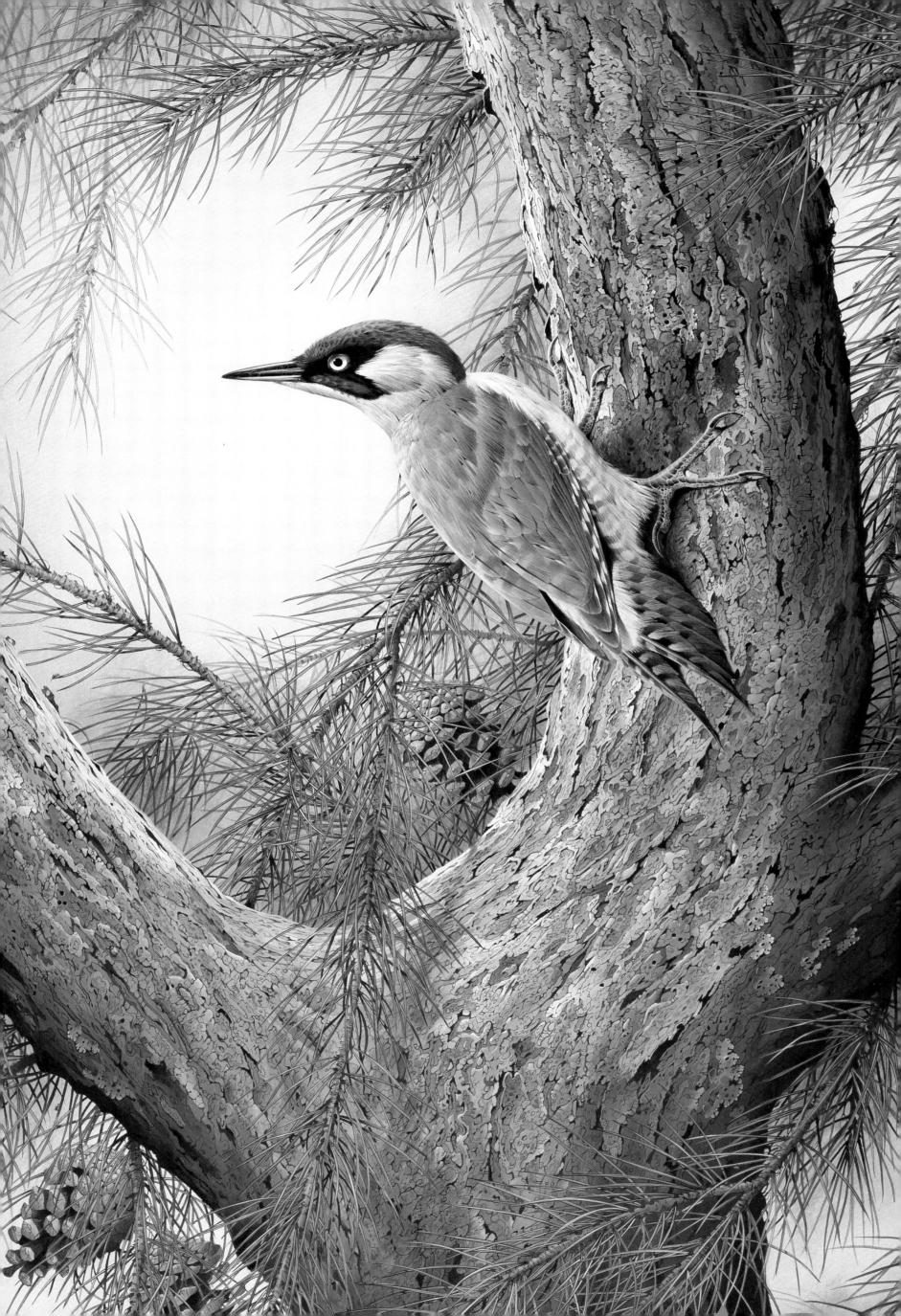

Tree Sparrow

I feel certain that a lot of people who live in rural areas and take an interest in natural things would say that they rarely see a Tree Sparrow, for it is considered to be a much rarer species than it really is. This is understandable as the correct identification of this bird can be tricky, because of its resemblance to its close relation the House Sparrow.

The most obvious differences in plumage when both species are compared are the Tree Sparrow's chestnut cap, white cheeks and a distinct black patch on the side of the head. It is also slightly smaller which gives the impression of a somewhat neater and tidier bird. The Tree Sparrow also prefers a more rural environment and is really more of a countryside bird than *Passer domesticus*.

Autumn is the time of the year when these birds tend to flock with House Sparrows around the edges of fields, gleaning the remaining corn from the harvest stubble. This is the season that I have chosen for my painting. The opportunity of using the browns and yellows of the maple tree adjacent to the bird's plumage was a colour combination that I had considered for some time. One of the difficulties a wildlife artist has when painting a picture that has a particular colour bias, is to decide whether the main subject matter of the work should follow that trend and thereby harmonise the overall image, or whether the subject should be so completely different in colour as to stand out vividly from the background, thus drawing immediate attention to what is after all the main object in the painting. I invariably adopt the former technique because I think that the overall uniformity of a painting will very often tempt the viewer to look much more closely at everything that has been represented by the artist.

Whilst on the subject of plumage, the four birds illustrated could be any combination of either sex as the colouring of the cock and hen birds is identical, unlike the House Sparrow.

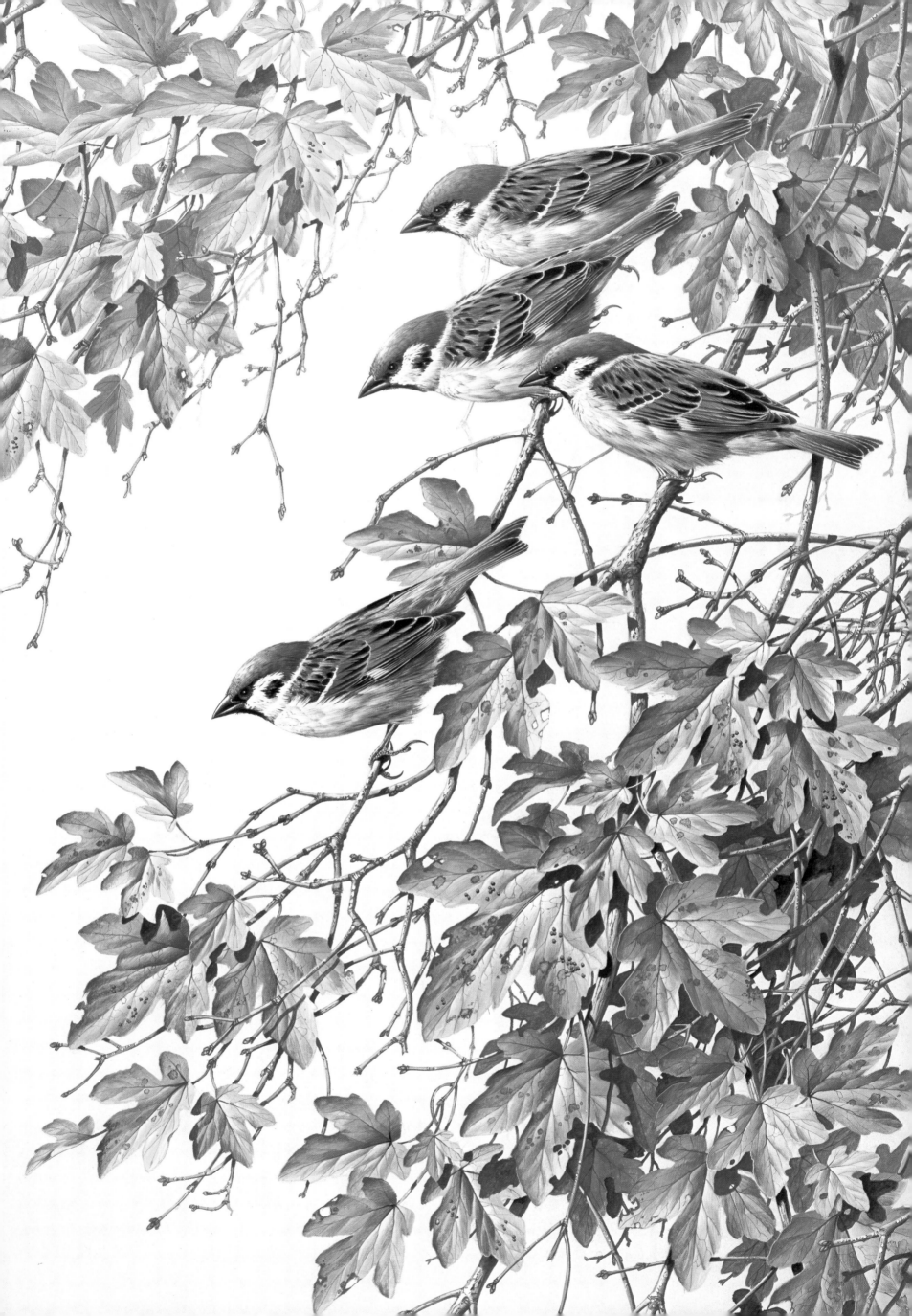

Nuthatch

From an artist's point of view, some birds give the impression that they have evolved into a particular shape and colour merely for his benefit. Other species present a combination of patterns and possess a physiology that defy any illustrator to get them right first time. The Nuthatch, I am pleased to say, falls into the former category and it is a bird that I always enjoy painting. This little sparrow-sized bird is a tree-dweller and, with the exception of an occasional foray at ground level or a brief visit to the birdtable, it spends the majority of its active life exploring trees in search of food. Its name is derived from the habit that the Nuthatch has of wedging an acorn or a nut into a crack in the tree bark and then going at it hammer and tongs with its woodpecker style beak! However, its food requirements are not too specialised and it will consume various seeds, assorted vegetable matter and insects with equal relish.

The Nuthatch shows a marked preference for large and mature hardwood trees and is very rarely encountered in coniferous woodland. As with the woodpeckers the species favours trees with a certain amount of decay or damage, and old chestnuts and oaks that are beginning to show their age are ideal. This bird is a hole-nester, but restricts itself to natural or man-made openings. It is incapable of drilling out its own nest hole in the manner of the woodpeckers and it will take quite readily to artificial sites, such as nest boxes, provided that they are in the right environment. If the hole chosen is too large the birds will adapt the size by plastering the sides with mud until it becomes almost tailor-made.

Trees are a passion of mine and the lovely thing about painting the Nuthatch is that I can incorporate a fair portion of tree trunk in the painting. The infinite range of textures and hues presented by all trees and their barks is always exciting, and in the painting opposite I have shown the birds on an old willow, a favourite tree of mine. The willow leaves are splendid from a compositional viewpoint and their characteristic shape strengthens the structure of the illustration considerably.

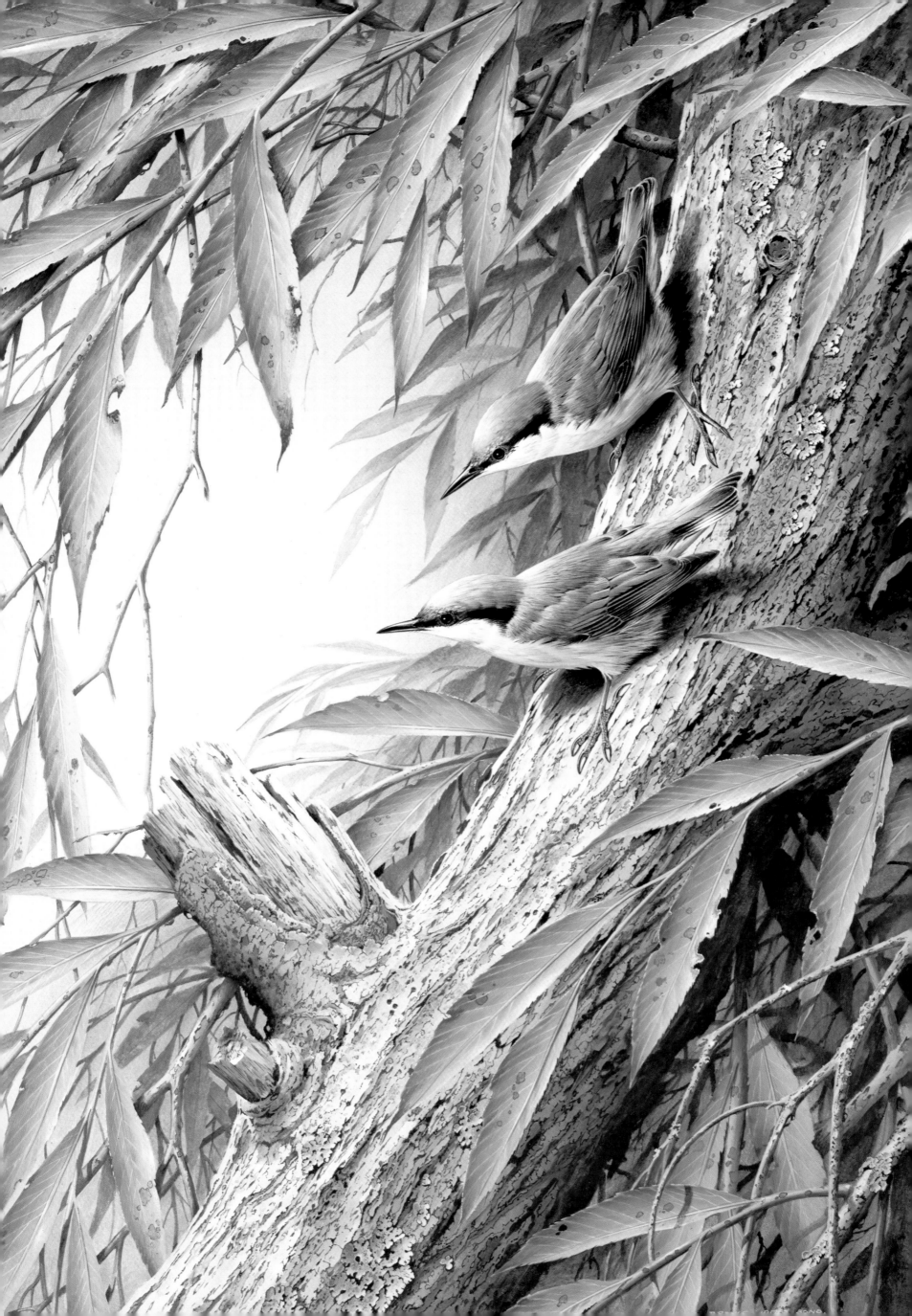

Blue Jay

The Blue Jay is one of the best known of the North American species. Like a lot of birds that seem to have made themselves conspicuous through their appearance or behaviour, it is either a favourite or not, depending on your point of view. The Blue Jay in common with most other members of the worldwide crow family is both an intelligent and a very cautious bird. While primarily a bird of forest and woodland, the jay has recently shown the degree of adaptability and integration that has made the *Corvus* family so successful throughout the world, and the Blue Jay can now be seen regularly in large gardens, city parks, and other urban and suburban locations. Most people become acquainted with it during winter as it has become a regular visitor to garden feeding-stations.

All crows are noisy birds and the Blue Jay is no exception, so the arrival of one at the birdtable will usually cause havoc amongst the smaller feeding species. The Blue Jay also acts as an early warning system for the natural environment; try to take a quiet walk through woodland in order to watch other birds or animals, and if a Blue Jay is present, then everybody and everything in the area will know that you are there!

The bird's plumage is very conspicuous. The tail and secondary wing feathers are of the brightest blue, and this is one of those pigments which gives the natural-history artist considerable trouble. The blue changes from one shade to another with every turn of the feathers, rather in the same manner as the colours alter on the Kingfisher.

Rather than try to compete with the brilliant hues of the bird's plumage, I have chosen to keep the background of the painting fairly understated and within a defined range of colour. The combination of birch and spruce trees also reflects the species' more natural environment.

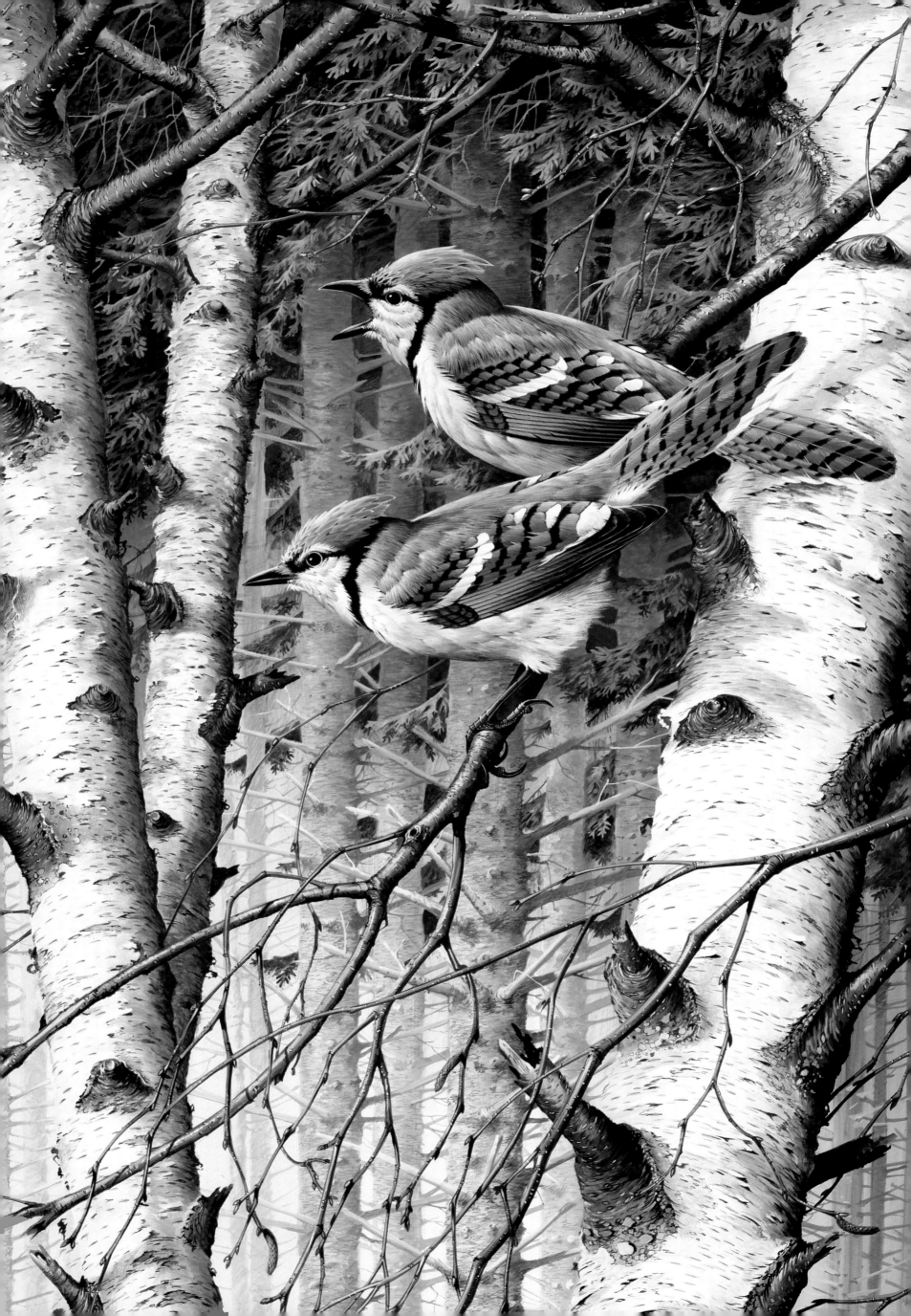

Warblers
(Reed Warbler, Sedge Warbler, Willow Warbler and Blackcap)

In Britain the small birds known as warblers are usually associated with the arrival of the warmer and longer days of spring. These little birds, summer visitors to the British Isles, travel from Africa to spend about seven months in Britain where they establish a territory, breed and raise possibly two broods.

Warblers are slim, neat, little birds, most of them being a fairly uniform greenish-grey or brown, or a combination of these colours. Nevertheless they are without doubt handsome birds and their discreet plumage patterns and overall well-groomed appearance present an attractive image. They are all insect-eaters.

The four members of the warbler family that I have selected are perhaps the most widely differing in appearance of the eleven species that visit Great Britain, and not surprisingly they enjoy differing habitats. The Reed and Sedge Warblers, as their names suggest, tend to prefer a more aquatic environment, the Reed Warbler *(top left)* probably being more closely confined to marshes and waterside vegetation than the Sedge Warbler *(top right)*. The latter will nest in areas of damp scrub, overgrown hedges and ditches.

The Willow Warbler *(bottom left)* arrives in Britain in mid-March making it one of the first of the family to return here for the summer. It is often accompanied by its close cousin the Chiff-Chaff. These two birds are very similar but the most striking difference between the two is their song. The Willow Warbler nests in mid-May, the nest is usually located low in the hedge row. Five to six eggs are laid in the single brood, although it is not unknown for there to be a second brood.

The Blackcap *(bottom right)* is the most arboreal in nature of this quartet and spends much of its time high up in the leaf canopy of broad-leaved woodland. Nesting, however, takes place nearer the ground, usually in some thick bramble bush or similar cover. Of all the warblers this particular member possesses probably the most melodious voice, and its warbling song has been compared by some with the Nightingale and Blackbird. In recent years there has been an increasing number of reports of the species over-wintering in Britain and it is occasionally seen at birdtables during really cold weather.

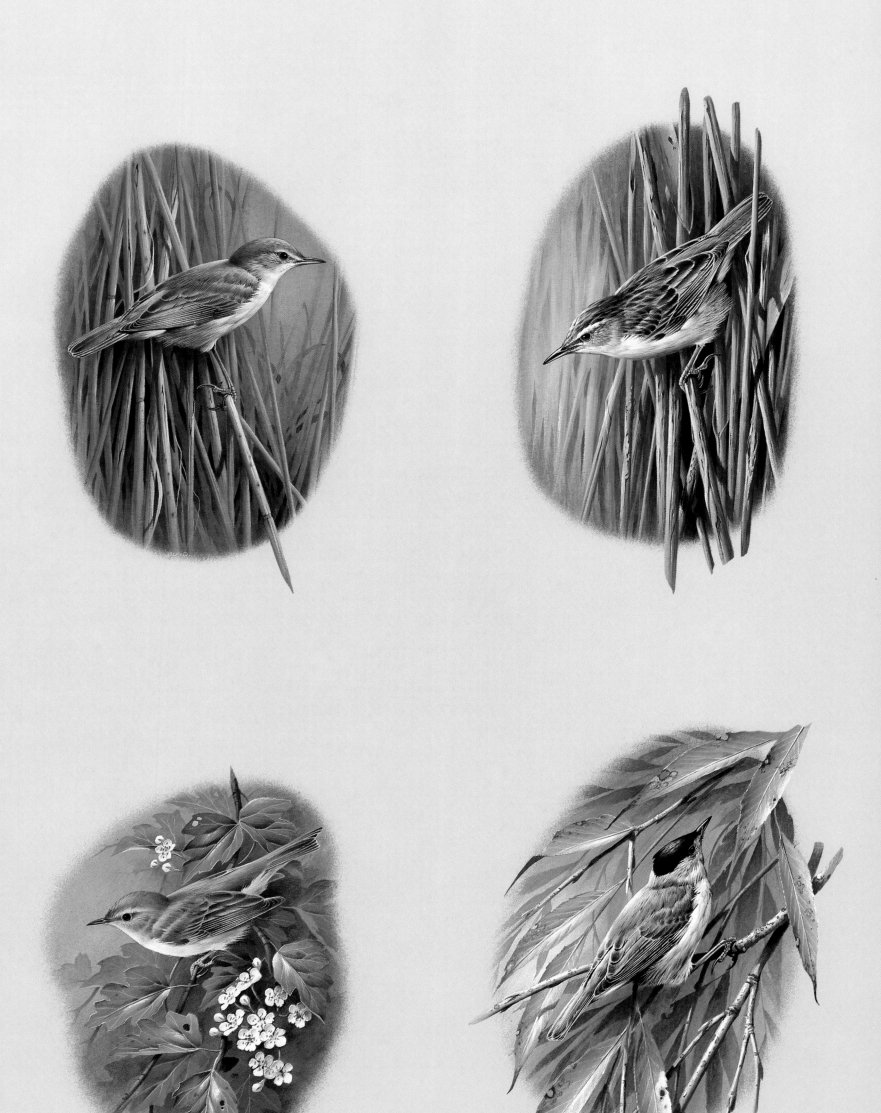

Swallows

The Swallows, Swifts and Martins are some of the most welcome summer visitors to the British Isles. They arrive from Africa at varying intervals during the spring from as early as mid-March to take up residence at nesting locations from the previous year. The most familiar of these visitors is the House Martin, a bird that is closely bound up with modern man and his buildings. They will form large, noisy colonies under the eaves of houses.

When I was a young man Swallows nested regularly in the open-fronted buildings around the stack-yard of my parents' farm. For this reason the Swallow to me will always be the best-loved member of the family. As if to reinforce this affinity with farm buildings and similar structures the species is known as the Barn Swallow in the United States of America.

In the painting shown here I have deliberately placed the birds against a fairly light and plain background of an old white-painted timbered building, a device which has helped accentuate the delicate and streamlined tail feathers of the adult bird. There is no obvious difference between the plumage of the male and female Swallow. The simplest way, however, to tell male from female is the length of the tail streamers; the male has the longest, the female the next longest and birds born during the year the shortest.

Old material, wood or stone, is always interesting to paint particularly if some decay or weathering has taken place, for besides adding a tactile element in the form of holes and cracks and their accompanying shadows, it also adds a sense of time to a particular scene.

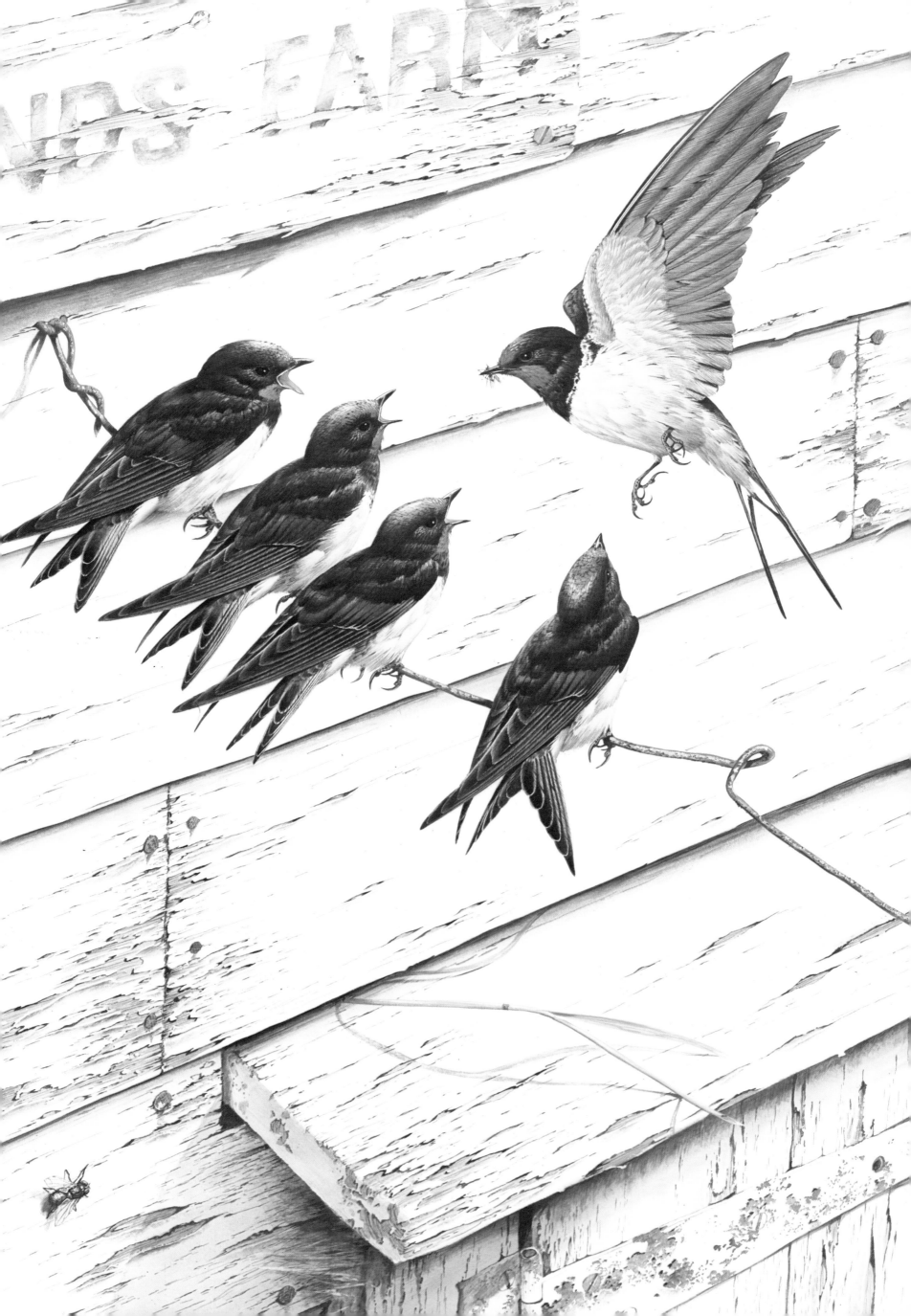

Redwing

The Redwing will always be a winter visitor for most British bird-lovers. It arrives in late September and through most of October to spend the winter and early spring in Britain. Whilst undoubtedly falling into the category of a cold weather bird, the Redwing will always remind me of those wonderful mellow days during early autumn, when the leaves on the trees are just beginning to change colour. The hot and dusty days of high summer are over and the rural surroundings are about to undergo as dramatic a change as they do during spring.

Hedges and trees are full of berries and fruit and as a consequence full of birds of every description taking advantage of this feast of seasonal protein. We had many hawthorn hedges on our farm and for me this particular shrub will remain permanently associated with Redwings and Fieldfares. I can remember being very frustrated as a young bird-watcher trying to study these continental thrushes through an old pair of binoculars, but the shy birds would always fly further along the hedge, or simply slip over to the other side. If I had learnt to stay still and sit and wait, the birds would eventually have quietened down and involved themselves with the task of feeding, replacing the reserves of fat used on their flight over from Scandinavia and Russia. Twenty-five years later, with an infinitely more sophisticated pair of binoculars, I watch Redwings and Fieldfares in my meadow feeding on the hawthorn berries, and these handsome thrushes still give me enormous pleasure when I see them for the first time during autumn.

As winter progresses and the wild fruits become scarcer the Redwings will search the fields and rural gardens for earthworms. In common with all the members of the thrush family, the worm is extremely important to them and forms probably their largest single source of protein. Of course, as with all worm-eaters, long periods of cold weather and frozen ground can present severe problems for the Redwing; for some reason the bird does not feed quite so readily on discarded apples and soft fruit as do the other thrushes. I do not think I can recall ever seeing one on my bird-table. During a bitterly cold month a neighbour of mine regularly brought me emaciated bodies of Redwings that she had found under a large holly tree adjacent to her house. The birds which were roosting in this bush during the night were quite simply dying of cold as a result of not having found sufficient food the previous day.

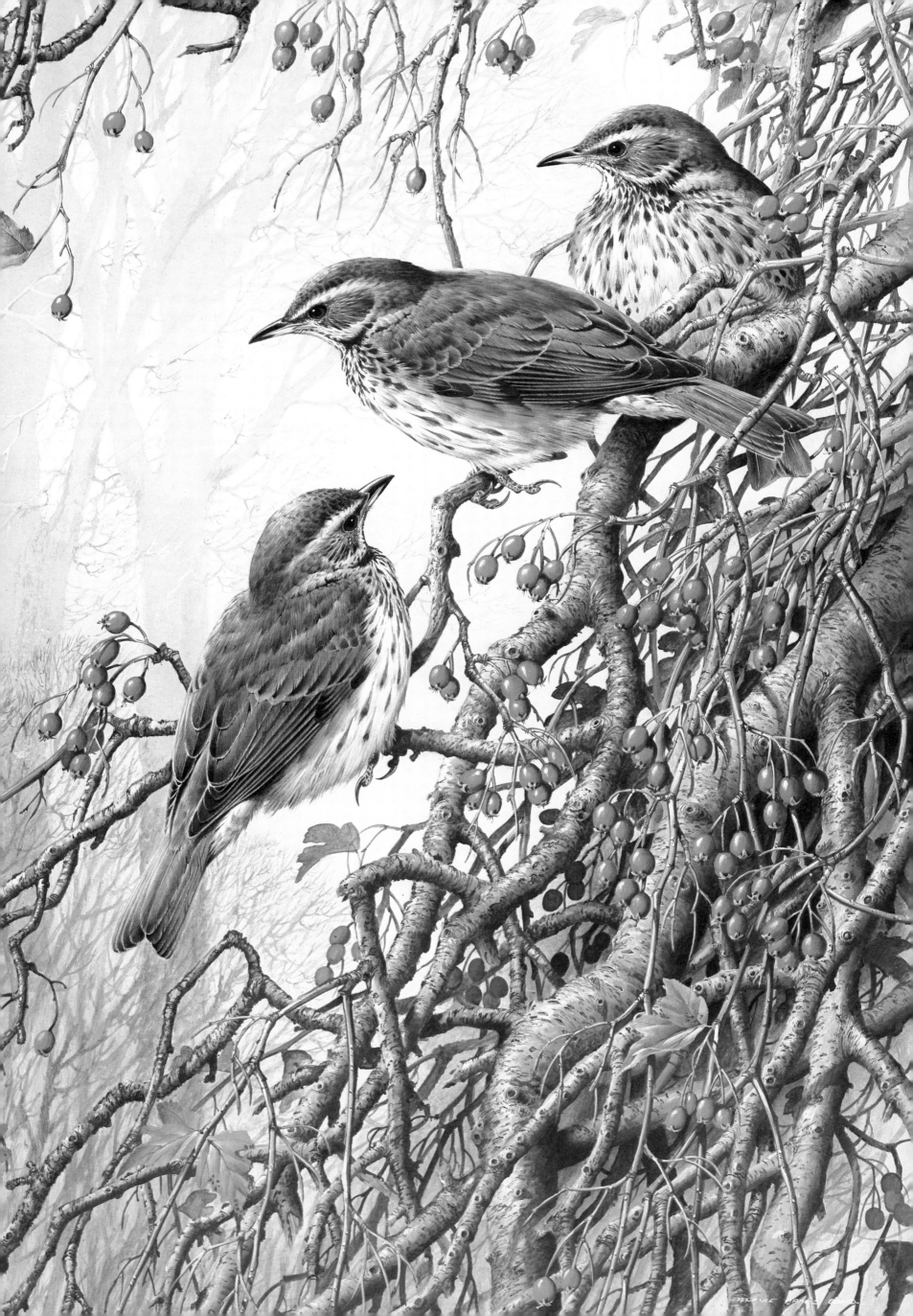

Fieldfare

Fieldfares are one of the largest and most colourful of all the thrushes, and also one of my favourite birds. Fieldfares and Redwings arrive in mixed flocks in autumn from Scandinavia and will over-winter until returning during April to breed in their native land.

The Fieldfare gives the impression of being a 'no nonsense' bird and even during the coldest of winters will somehow survive whilst its less adaptable cousin the Redwing will often succumb to the cold weather. During the worst of the winter months I ensure that there is food of a mixed variety available every day, seeds, nuts, fat, table scraps and old fruit. Some of this is placed on a large birdtable suspended under a willow tree, and the remaining food is scattered on the ground in other areas of the garden. The reason for this is that many of the woodland birds that venture into the gardens during winter prefer to find their food at ground level. Robins, Titmice and Greenfinches, all leap about and make a general commotion on the birdtable, other species, including the Fieldfare, will feed on the ground.

Apples are a favourite food for this bird and I have watched a single Fieldfare stand guard over an apple and despite being out-numbered several times, successfully defend its prize from Blackbirds and Mistle Thrushes. Similarly just before the more severe frosts one year, a pair of birds took up station in an ornamental flowering crab apple tree, which at this time was festooned with bright yellow grape-sized fruit. These two Fieldfares remained in possession of this small tree for some ten days until the majority of the fruit was consumed, only then did they relent slightly and allow the occasional Blackbird to have some of the left-overs.

Regardless, however, of this seemingly demonstrative and aggressive behaviour to other birds, the Fieldfare is rather shy. Unless forced by continuous cold weather, it would prefer to feed away from human habitation, and only on occasions is it found in the gardens of town houses.

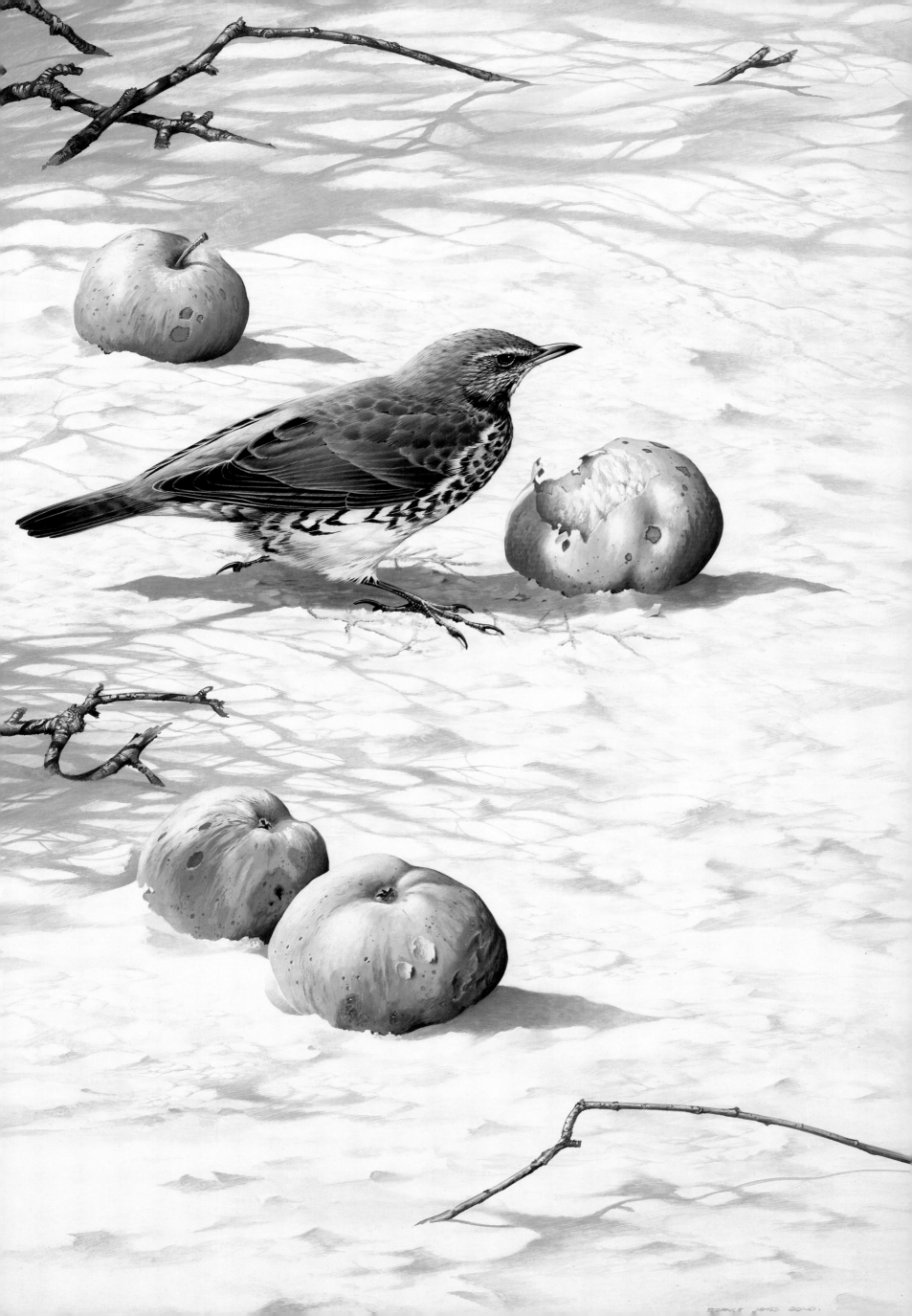

Cock Pheasant

The Pheasant is one of those birds whose natural distribution has been widened from its origins in the Far East to encompass most temperate and sub-tropical climates. The species is purported to have originally been introduced to Europe and subsequently the United Kingdom by the Normans during their conquering travels. They in turn presumably obtained the bird in China and Mongolia, the bird's home territory. The facts will probably always be uncertain, but one thing that is known is that there were originally two or three distinct races or forms introduced at varying intervals from different parts of the world. The two dominant types were the 'Chinese' or 'Ring Neck' Pheasant, as it has become known, and the 'Mongolian' race of 'black' Pheasant which has no white neck ring. Confusingly the former is now sometimes referred to by sportsmen as the 'Old English' Pheasant. The question of races and how many there actually were is academic, for since their introduction over the past several hundred years, the respective types have inter-bred so many times that given a selection of a dozen cock birds, they will all probably differ to a greater or lesser extent in plumage colouration, white neck ring or not.

My illustration opposite depicts a mature cock bird in a typical winter hedgerow setting somewhere in the south of England and just to be on the safe side I have shown a white ring neck variety – if I hadn't someone would be sure to say, 'Yes, very nice, but what happened to the ring?'

The main reason for this widespread distribution to such places as Australia, Europe, Canada and the Americas was not in any way connected with science. The thinking behind it was more funda-mental – any bird that can be semi-domesticated, grow to a weight of four pounds or more in a single season and produce anything up to two dozen offspring, is a viable food source, and in some cases, the handsome male of the species may even have been kept as an impressive garden ornament. These days thousands of Pheasants are reared commercially under artificial conditions in order to provide sport for shooting syndicates and large agricultural estates.

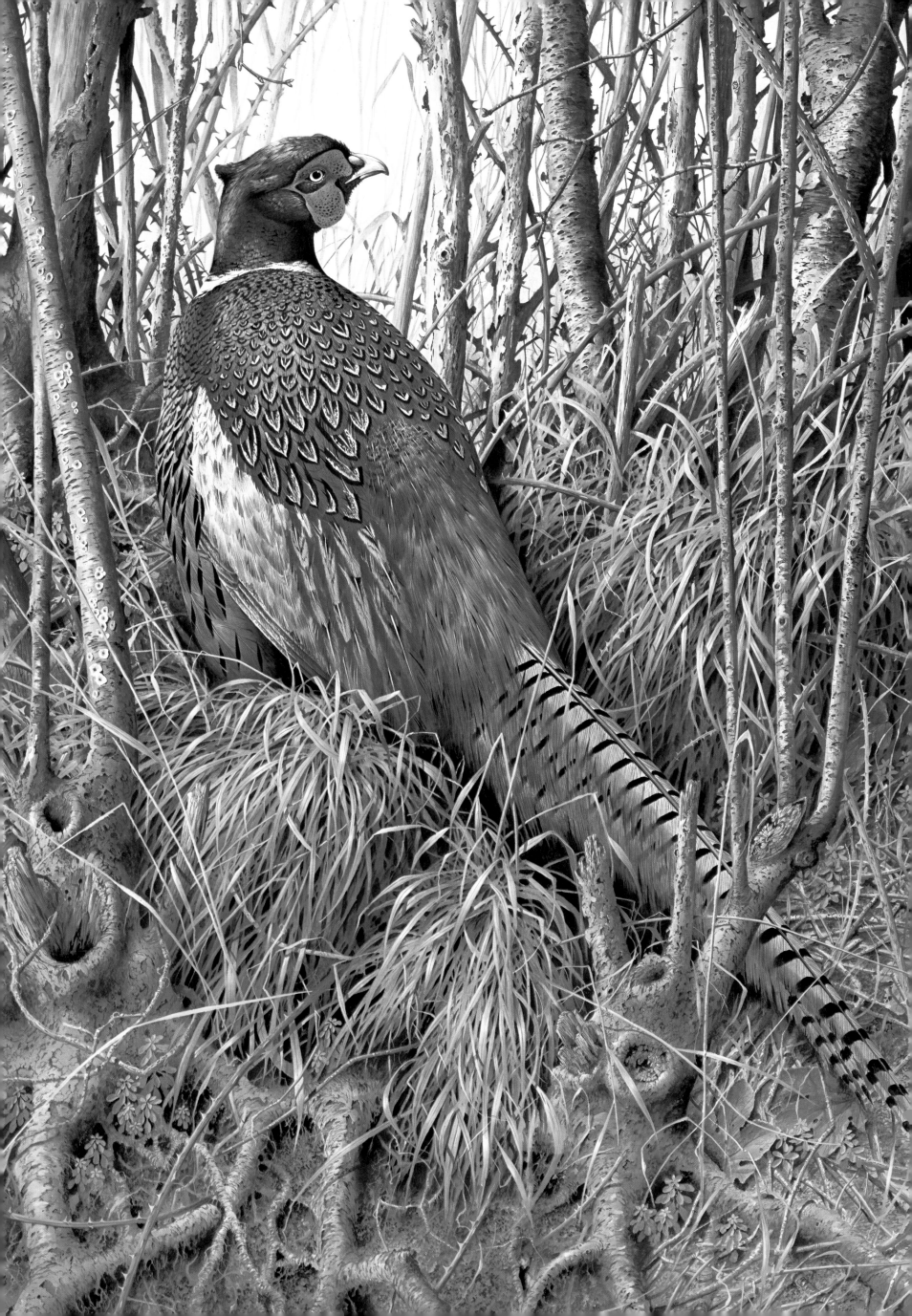

Red-Legged Partridges

This European species was introduced to the British Isles sometime around the seventeenth century, unsuccessfully at first, but a century later a second attempt proved successful and today in southern England the Red-Legged Partridge is established as a resident breeding bird. It was the large landowners who were responsible for the introduction of the bird in order to supplement our own native partridge, the English or Grey, whose numbers were beginning to decline in some areas. The 'Frenchman', as it became known, is a slightly larger bird than the English Partridge and seems able to adapt more easily to intensively farmed agricultural areas of England. Primarily the bird's food consists of vegetable matter, weed seeds, grain and the like, but insects and grubs also form a regular, if smaller, proportion of the diet.

The nest is usually located at the base of a hedge or similar thick cover and two broods of up to fourteen can be considered normal. A peculiarity of the species is the habit of producing two broods in separate nests, the first clutch of eggs being incubated by the male.

The painting opposite is an example of the artist being stimulated to embark on a particular picture by the sight of certain objects that might otherwise not be connected with bird illustration. The pile of sawn logs is located in the corner of my meadow and is a neighbour's store of winter firewood. Such a natural material arranged in a commonplace but contrived way was visually pleasing, and for some time I had been considering the possibilities of using this idea in a suitable painting.

Despite the brilliant colouring and very handsome appearance of the Red-legged Partridge, it is extremely difficult to see against a background of arable farmland or autumn leaves. On more than one occasion I have very nearly suffered a minor heart attack as a pair of birds, that had been dust-bathing by this very log pile, exploded away in a whirr of wings from my feet as I walked through the meadow.

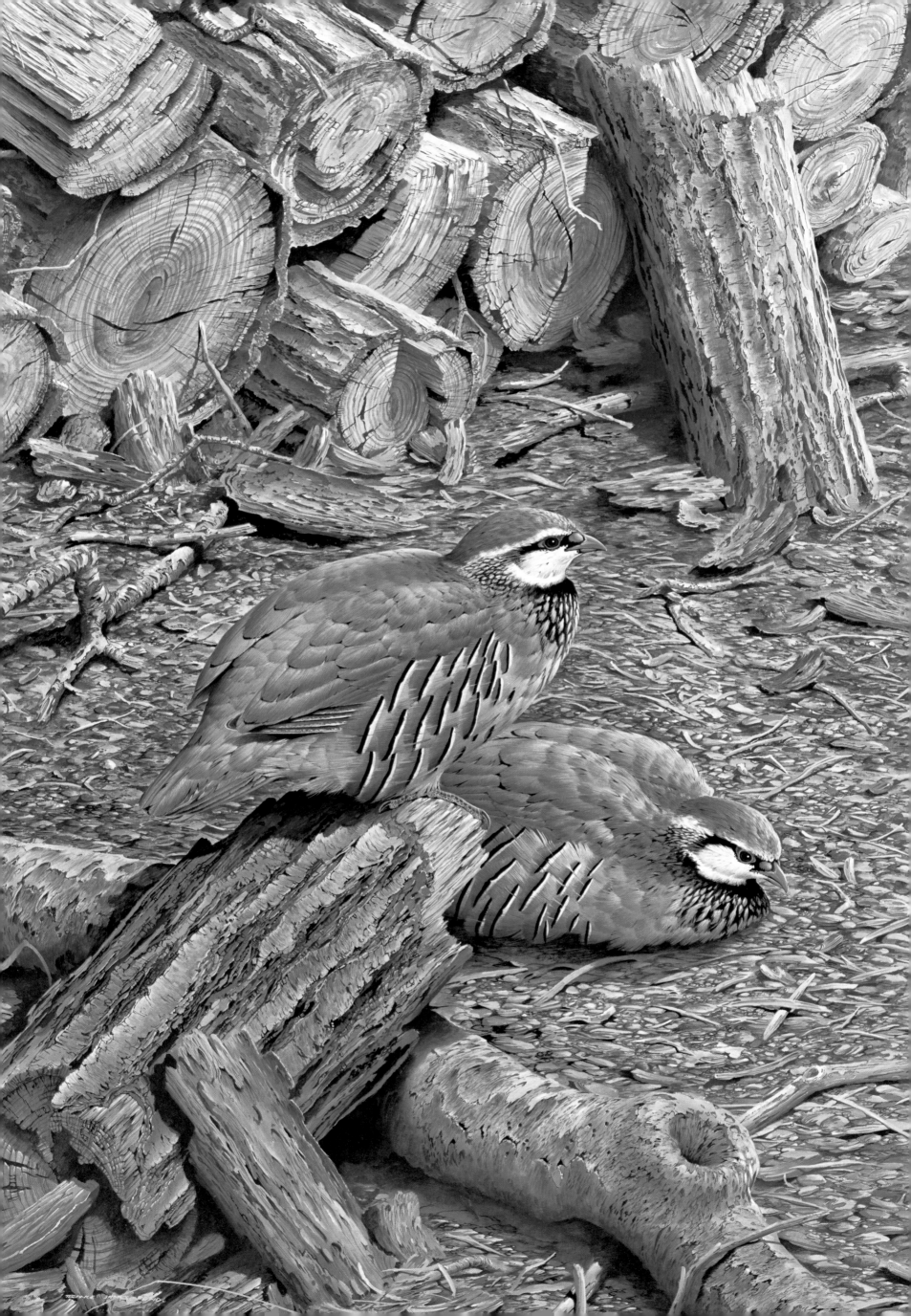

Birds of Prey

Birds of prey provoke fierce reactions. Some feel that they exemplify the old saw 'Nature red in tooth and claw'. However, for many, myself included, they epitomise elegance, power and consummate flying skills.

A Kestrel, for instance, will not catch and kill a fieldmouse just for fun; it takes the prey because it is hungry or to feed offspring, and not for any other reason. In order to perform as efficiently as possible the Kestrel, along with the other raptors, has certain stylistic developments that include large eyes, sharp claws and hooked and powerful beak. These are the bird's tools, its equipment if you like, for performing what in some cases can be a difficult and hazardous job. It is just unfortunate that to some people these physical properties give most birds of prey a rather mean and fierce appearance, and as a result the bird is assumed to have a personality to match.

The binocular vision of birds of prey is truly remarkable, in some cases up to five times more acute than our own eyesight. This is important for a bird that is hunting over a large area, possibly from high altitudes, and searching for an item of prey as small as a grasshopper or a field vole. A Golden Eagle, for example, may soar as high as 5,000 feet and be quite capable of spotting an animal the size of a mountain hare in the glen below. This is the equivalent of our noticing a domestic cat at a quarter of a mile – possible perhaps if the cat were not well camouflaged and moving, but a well-hidden hare or rabbit a mile distant? Something entirely different!

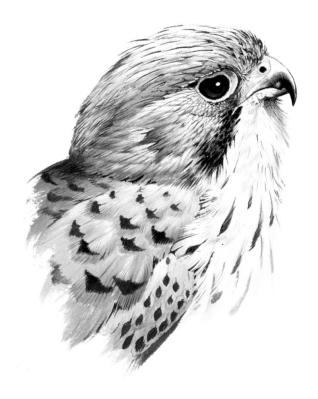

Allied to the extremely sensitive eyesight is a second very well-developed sense, that of hearing. In most birds of prey the ears are highly developed organs, particularly so in the owls, which, whilst possessing the extremely good vision of a predator, are very often prevented from utilising it to maximum advantage simply because on a cloudy moonless night it is too dark. Most owls are quite capable of locating their prey using their highly developed hearing, coupled with a minimum of visual assistance.

Birds of prey have one common goal; to capture and kill live prey. Despite this, they vary enormously in body shape, wing design and the size of legs and feet. This is because birds of prey are at the top of what is known as the food chain. Competition at the top of such a chain is intense. Thus birds of prey have had to develop specialised diets and means of hunting in order to survive and this has resulted in their wide variety of shapes and sizes.

Falcons are the most spectacular hunters, and their general appearance has evolved to suit their lifestyle. Long pointed wings and relatively short tail enable most of the members of the *Falconadiae* group to fly and climb fast. Most Falcons kill simply by out-flying their intended victim, grasping it with very powerful feet, flying to a convenient tree or rock and despatching the prey with a bite through the base of the skull. The beak of all Falcons has a specially developed tooth on the upper mandible with which to perform the *coup-de-grâce*.

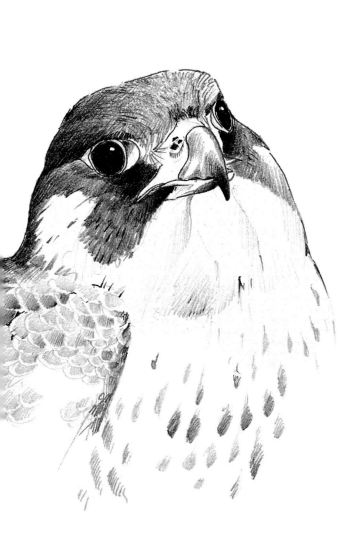

Peregrine Falcon

The Peregrine Falcon is a very successful bird both in terms of distribution (it is found throughout the world) and in its ability to adapt to a variety of environments. It is, therefore, hard to believe that about twenty years ago the Peregrine was in very real danger of becoming extinct in North America and parts of Europe, particularly Great Britain. There were many factors in the near destruction of some countries' breeding Peregrine population.

By the middle of the 1960s tremendous progress had been made in agricultural production. Europe and the New World were now highly efficient and in the happy position of being able to export foodstuffs in huge quantities, mostly cereals, to countries that were unable to grow sufficient food for themselves. For a while everything in the garden seemed to be lovely.

However an alarming and ominous phenomenon was about to reveal itself in a most unlikely guise. During the 1960s bird watchers and ornithologists in the United Kingdom and the United States of America were reporting an increasing number of cases of Peregrine Falcons that were failing to hatch their eggs successfully. The clutch was in fact breaking soon after it was laid, and as a consequence the parent birds were deserting the nest. In the space of only a few years the residential population of Britain's Peregrines had been reduced by fifty per cent and the rapid decline showed no signs of slowing down. Just when the situation seemed hopeless a team of scientists working for the British Trust for Ornithology discovered that the reproductive system of the female Peregrine Falcon had been affected by the build up and accumulation of certain toxic residues. The production of calcium for the formation of the egg shells had been retarded and the result was that thin-shelled eggs were being laid and invariably broken during the normal course of incubation.

The new generation of synthesised chemicals, the organochlorine pesticides and the dieldrin-based seed dressings, was eventually acknowledged as the main cause of the trouble. Ironically it was the new pesticides and seed additives that had contributed so much towards the tremendous success of modern agriculture, and the production of higher yields than ever before. The problem was this: small animals, seed-eating birds and other invertebrates were consuming the chemicals through their normal diet and in turn were being caught and eaten by predators such as the Peregrine Falcon. The Falcons, being at the top of the food chain, over a period of months and sometimes years, were slowly ingesting the toxic chemicals, with the unforeseen, but inevitable, results.

The current situation is much improved with the worst of the offending chemicals and compounds now either banned or withdrawn. With the undertaking of a vigorous conservation and protection scheme, the breeding population of the Peregrine Falcon is in some areas now established at levels almost approaching pre-war numbers.

The Peregrine Falcon is without doubt a beautiful bird and, when seen live at close quarters is very impressive. Whilst not quite the largest of the Falcons, it is certainly one of the most powerful and unquestionably the swiftest. Whole books have been written on the subject of Peregrine Falcons and their hunting techniques and velocities have been quoted for the bird's legendary hunting swoop that are at best slightly optimistic and at worst totally exaggerated.

Suffice it to say that the bird is capable of achieving very high speeds during a full power dive and reliable sources put this at anything between 75 and 150 miles per hour. When you consider the weight of an adult Peregrine, between 1½ lbs and 2 lbs, travelling at something around one hundred miles per hour, then it is little wonder that sufficient kinetic energy is generated for prey animals to be struck and killed that are often several times larger and

heavier than the Peregrine Falcon. Peregrine Falcons, however, often simply out-fly and out-manoeuvre the intended victim, grasp hold of it with their very powerful feet and fly to the ground and kill the prey.

The bird's nest is usually located on a fairly remote and inaccessible cliff ledge and normally consists of no more than a scrape in the soil surface. On occasions, however, the Peregrine will adopt a nest formerly occupied by Ravens or Buzzards. Three or four eggs are usual and incubation lasts about thirty-two days with the fledged young leaving the nest after a further forty days or so.

The bird shown in my painting is an adult male (the female being slightly larger and with a hint of salmon pink to the underside and flanks) calling from what could be a potential nesting site. As can be seen, various shades of grey are the predominant colours in the picture, but I felt this worked well. The high points of the painting are, of course the bird's head and feet. Apart from being the most important part of a Falcon's equipment, they also lend a note of relief to the painting by being bright yellow. The branches of the Scots pine introduce an extra colour and a different element in the form of foliage and help soften what is otherwise a very strong composition.

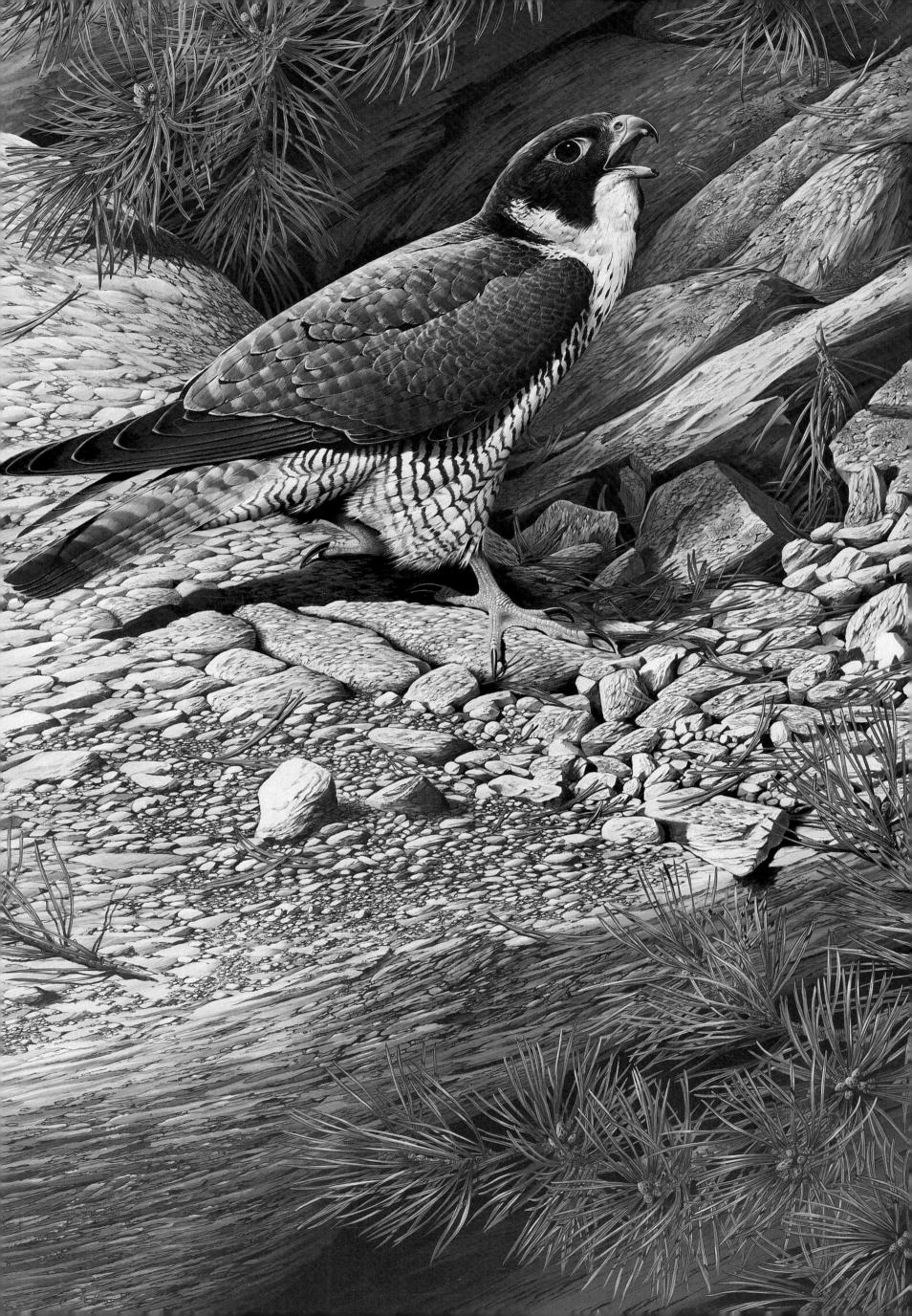

Hobby

The British bird population undergoes a marked change during the months of early spring when our resident species are supplemented by a wide selection of summer visitors. One of the more exciting and rare of these is the Hobby.

The Hobby is a Falcon and is approximately the same size and weight as its more common cousin the Kestrel. There, however, the similarity ends. The hunting technique of this bird is truly falcon-esque. It pursues and catches insects and small birds in flight; members of the swallow and swift family are regularly taken, which shows how fast the Hobby can fly.

As a British breeding species this bird is more-or-less restricted to the southern counties of England, and the preferred habitat would seem to be fairly open downland that contains a sprinkling of mature trees and small woods in which the birds will roost and nest.

The Hobby seems to follow a characteristic of many other birds of prey with regard to nests in that it does not construct its own but will adopt an old or abandoned structure usually belonging to a Crow. One brood of between two and four young is usually reared from about June onwards. Just around the time that the young birds are beginning to grow strongly and require large amounts of protein, an abundant food source is made available in the form of another summer visitor. Inexperienced and comparatively slow young Swallows are also on the wing and many fall easy prey to this expert hunter. Skylarks apparently are also a preferred food item. During the fledgling period it is the male that supplies most of the food for the young and also for the female; she confines most of her activities to brooding and maintaining a presence within the vicinity of the nest.

Most of the birds have departed from these shores by the end of September and migrate further south to over-winter in southern Europe and Africa.

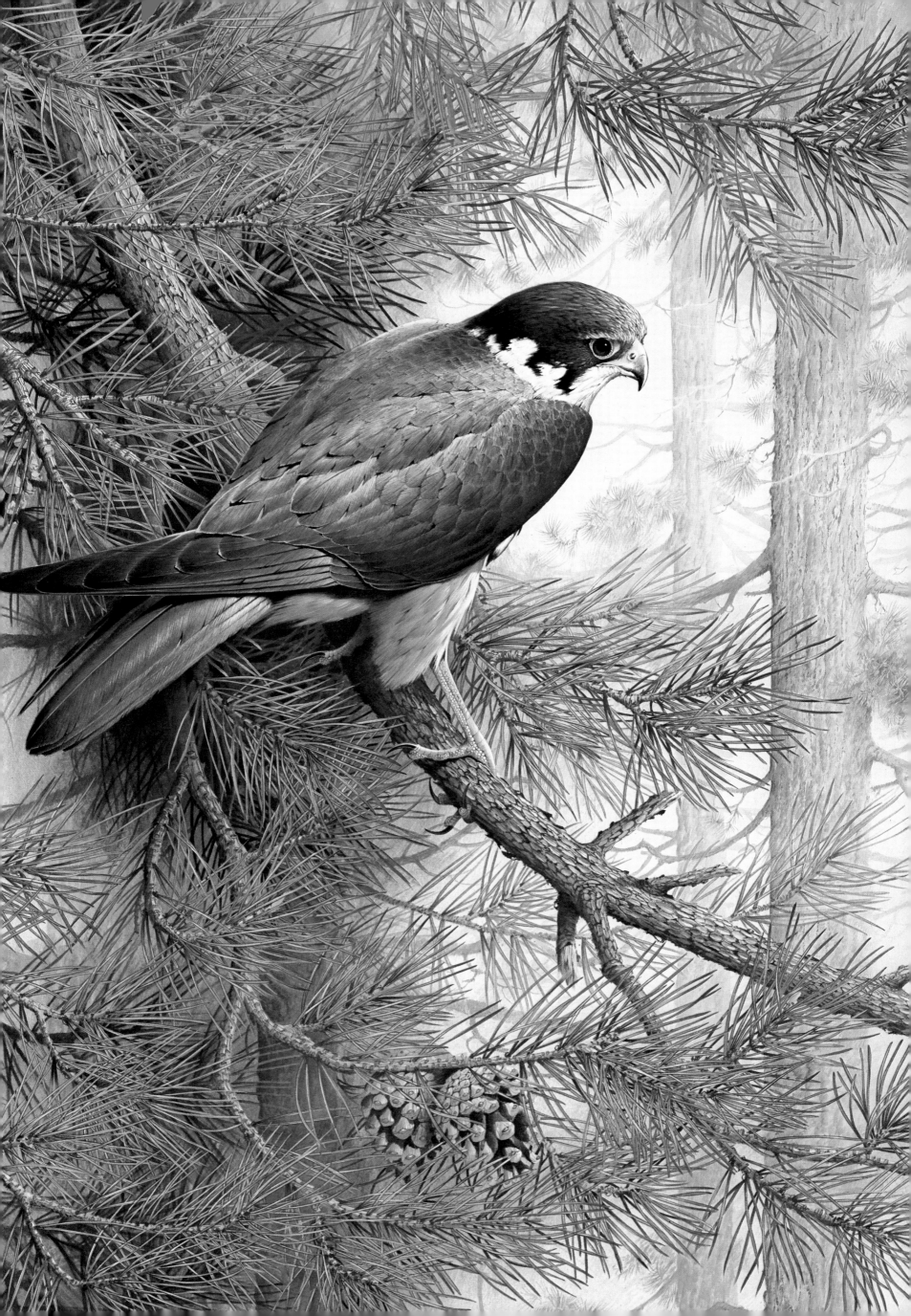

Kestrel

The most common and widespread of the Falcons is the Kestrel, and it is the one Falcon we are most likely to see more-or-less every day. It is the Kestrel's prime method of hunting that makes the bird so conspicuous as it is the only Falcon, or bird of prey for that matter, that habitually hovers in search of food. 'Hovering' is actually a slight exaggeration, the bird in fact has perfected the act of flying into the wind at the same speed as the oncoming air currents and therefore gives the impression of hanging almost stationary. This controlled hover is remarkable to observe through binoculars. At close range it can be seen that the bird's head remains fixed above a given point but the position of the body, wings and tail are constantly varied to compensate for any turbulence or change in wind speed. Watching through powerful field glasses from my studio window, I have studied my local pair of kestrels hundreds of times as they quarter and hover over my meadow and the pattern of flying is always similar. Firstly the bird uses a seemingly leisurely style of flight as it makes a reconnaissance of the ground below. Then it glides upwards a few feet and seems to hang itself on an invisible hook. Following a period of hovering, lasting from as little as five seconds to as long as two or three minutes, the Falcon sideslips away, always downwards, and then resumes the original flying mode until it repeats the whole fascinating procedure a few yards further up the meadow.

Kestrels will eat almost anything animate from beetles, grasshoppers and large insects, to small ground-dwelling mammals and occasionally small birds.

A wide variety of nesting sites will be used by the Kestrel but the preferred location is a large hole in a tree, usually at some considerable height from the ground. Other common nest sites include church towers, farm buildings, ledges or holes on suburban buildings and occasionally nest boxes. Every spring a pair of birds sit in and generally take great interest in a permanent nest box placed in an oak tree in my meadow, but for some reason as yet they have not actually used it for the purpose for which it was designed!

Four to five eggs constitute the average clutch and once the final egg has been laid the female will incubate for about twenty-eight days. Depending upon the brood size, the young will fledge and leave the nest in approximately a further thirty days.

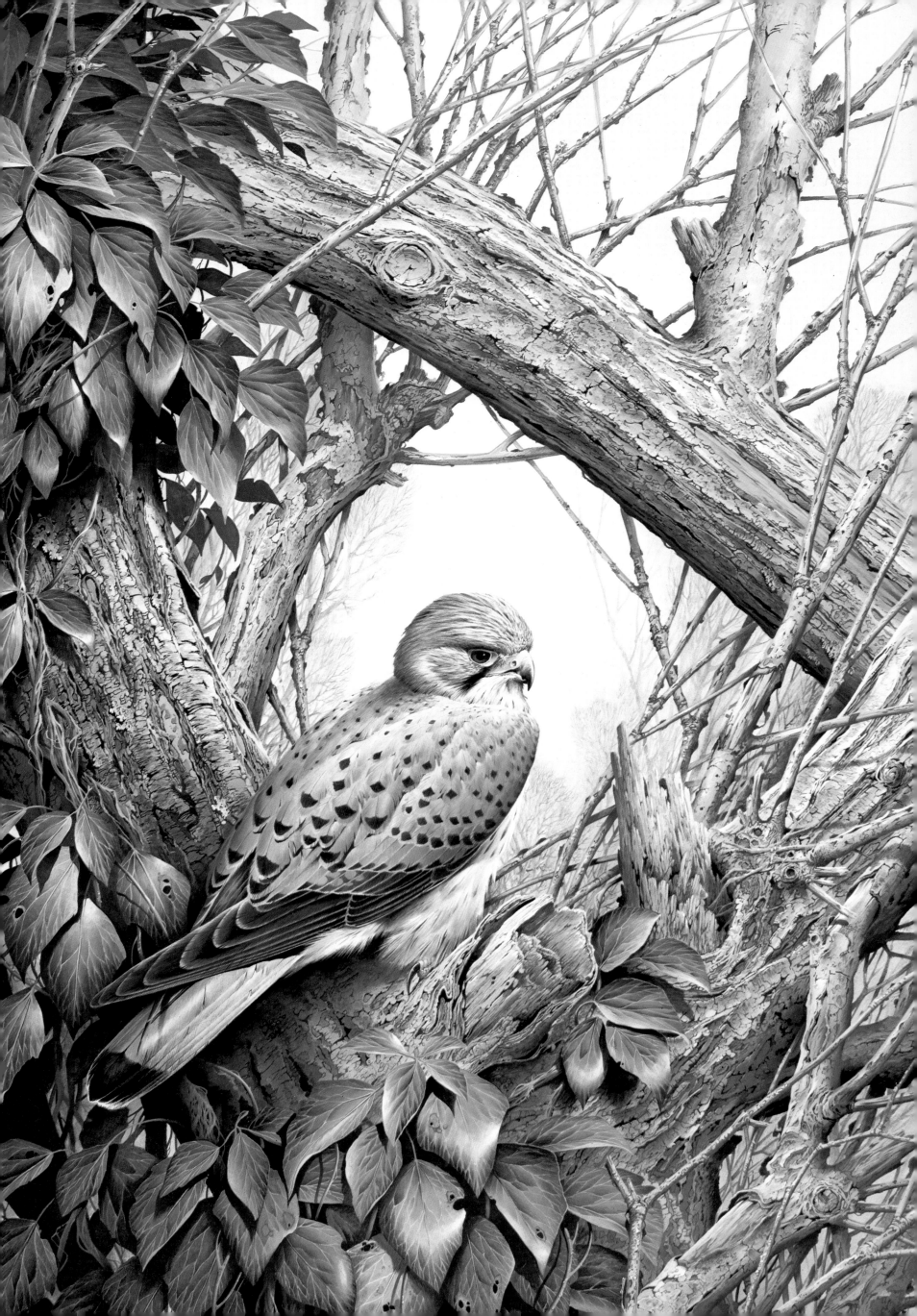

American Kestrel

The list of birds of prey that occur in the United States and Canada is impressive and many of the New World birds of prey are very closely related to the birds on the European list. Some, in fact, are the same species. The smallest and most widespread North American falcon is the American Kestrel (at one time referred to as the Sparrowhawk). The bird is somewhat smaller than the European Kestrel but is more colourful.

The species is well integrated with rural life and can be found in parkland, farmland and the margins of towns and villages. To hint at this association with modern man I have chosen to illustrate my male bird against a setting of sawn logs. This I feel works very well, the firewood is a perfectly natural element but the presence of civilised man is suggested through the obviously unnatural arrangement of the timber. The bird could be sunning itself in somebody's farmyard or rural garden and has taken advantage of the perching point whilst it sits and waits for the arrival of a potential snack.

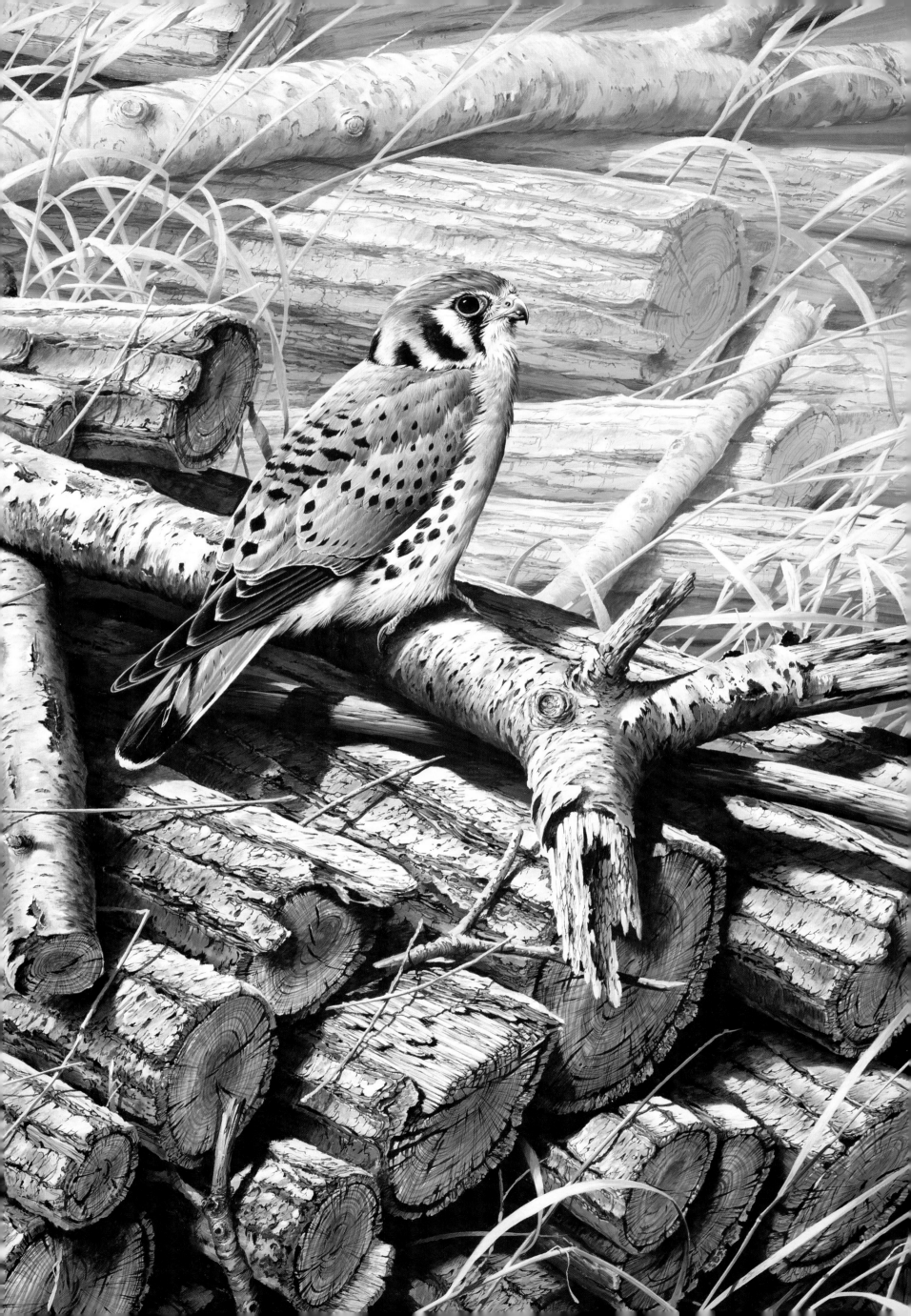

Owls

Owls are the nocturnal birds of prey, the night-time counterparts of hawks, eagles and falcons. Most people, however, seem to consider them with completely different emotions from those associated with the daylight predators. Owls have had a long and complex relationship with man; for generations they have featured in literature, paintings and folklore, and have been credited, justly or otherwise, with many differing attributes and powers.

In children's stories and rhymes the owl is often portrayed as being somewhat aloof, unapproachable and invariably possessing a high degree of intelligence. The 'wise old owl' is a saying that has become universally accepted and if an animal is to be adviser, consultant or teacher the owl is given this role.

Mystery also surrounds these birds. As creatures of the night (which the majority of them are), they have become associated with nocturnal activities of a slightly sinister quality. All too often film-producers and script-writers who wish to add a touch of menace to a particular night-time scene will add the hoot of an owl to build up the atmosphere.

Owls have an added affinity with the human race because of their appearance. They are for instance the only birds that seem to possess a 'face'. The large eyes placed on either side of the beak resemble the position of human eyes and nose. The upright stance the owl adopts when perching adds to its human-like appearance. In this respect it is like the penguin which also has an almost human appearance in its stature.

Most owls conform to a universal 'design', with a similar basic structure. They are unable to exploit the various hunting techniques and different food sources that daylight predators enjoy, and consequently they have evolved in a more consistent form.

Other birds, particularly small ones, seem to have no trouble in recognising the owl's more obvious physical attributes. A tawny owl, for instance, that has been *discovered* roosting during the day by song birds will immediately be subjected to a cacophony of alarm calls and aggressive displays. Within a short time most of the neighbouring residents will join in the general harassment until, unable to withstand the intrusion any longer, the owl will quietly slip out of its sleeping place and drift away in search of a more peaceful site. Blackbirds, thrushes and finches are quite likely to pursue the owl until this potential threat has moved out of their territory.

In common with all other birds of prey owls have their share of problems. Not least is the continual destruction of their habitat and the unfortunate attitude that many people have with regard to a predatory species of any kind. Along with many of the falcons and hawks, owls are now considered to be a group of birds in need of greater protection, and further study is needed if we are to understand better their particular requirements and the specialised place they occupy in the natural order. Many people have an ambivalent attitude towards such species, and because they do not understand the necessity for birds of prey to exist in the natural world continue to persecute them. The only way that this situation will change or improve is by education and through a greater awareness of the interacting relationships and functions of the animals and birds which share this planet with us.

Four of my owl paintings are reproduced in the following pages and while each of the birds is different in colour and size, their basic build is typical; general upright posture, apparently no neck, a large head with forward-facing, very obvious eyes and accompanying facial discs. Naturally they have the other two prerequisites of any bird of prey, a strong hooked beak and well-developed feet and claws.

Little Owl

Despite the fact that the Little Owl is the smallest of the six species of owls resident in Britain, it is the most likely to be seen. When not actually hunting, the Little Owl will spend long periods just sitting, surveying the immediate surroundings from a suitable vantage point. In many areas during recent years hedgerows have been removed and trees have vanished as roads have been improved and agriculture intensified, and so the only things left standing may be telegraph poles.

I can recall cycling in eastern England when I was still a schoolboy and the sight of Little Owls sitting on top of roadside poles was commonplace. Indeed, if one wished to see a Little Owl, telegraph poles were the best place to look. Unperturbed they sat motionless, save for a mechanical swivelling of the head to peer at me as I cycled past, and continued to stare with fierce yellow eyes as I receded from view.

Little Owls are relative newcomers to Britain. They were introduced during the nineteenth century, unsuccessfully at first, but breeding colonies were soon established in Northamptonshire and Kent. Although absent from Ireland and rare in Scotland, Little Owls are now fairly widespread throughout southern and central England.

Little Owls are primarily birds of agricultural areas, parkland and some coastal regions. Well-timbered hedgerows with mature trees provide their most favourable habitat. Nesting is more likely to occur in holes in trees, but if there are none available, these enterprising birds will adopt farm buildings, rabbit burrows or similar holes in which to lay three or five white eggs. Incubation lasts approximately twenty-eight days and the young birds are fledged after about a further thirty days.

Some years ago gamekeepers and landowners whose land was used for shooting claimed that game-bird chicks were being destroyed by predator owls. This resulted in intensive research by the British Trust for Ornithology to establish just what the owl did eat. Contrary to general belief it was proved that the diet of the Little Owl, in common with that of many of the birds of prey, consisted of insects – moths, cockchafers, craneflies, etc – supplemented with ground-caught prey such as earthworms, beetles, voles and other mammals.

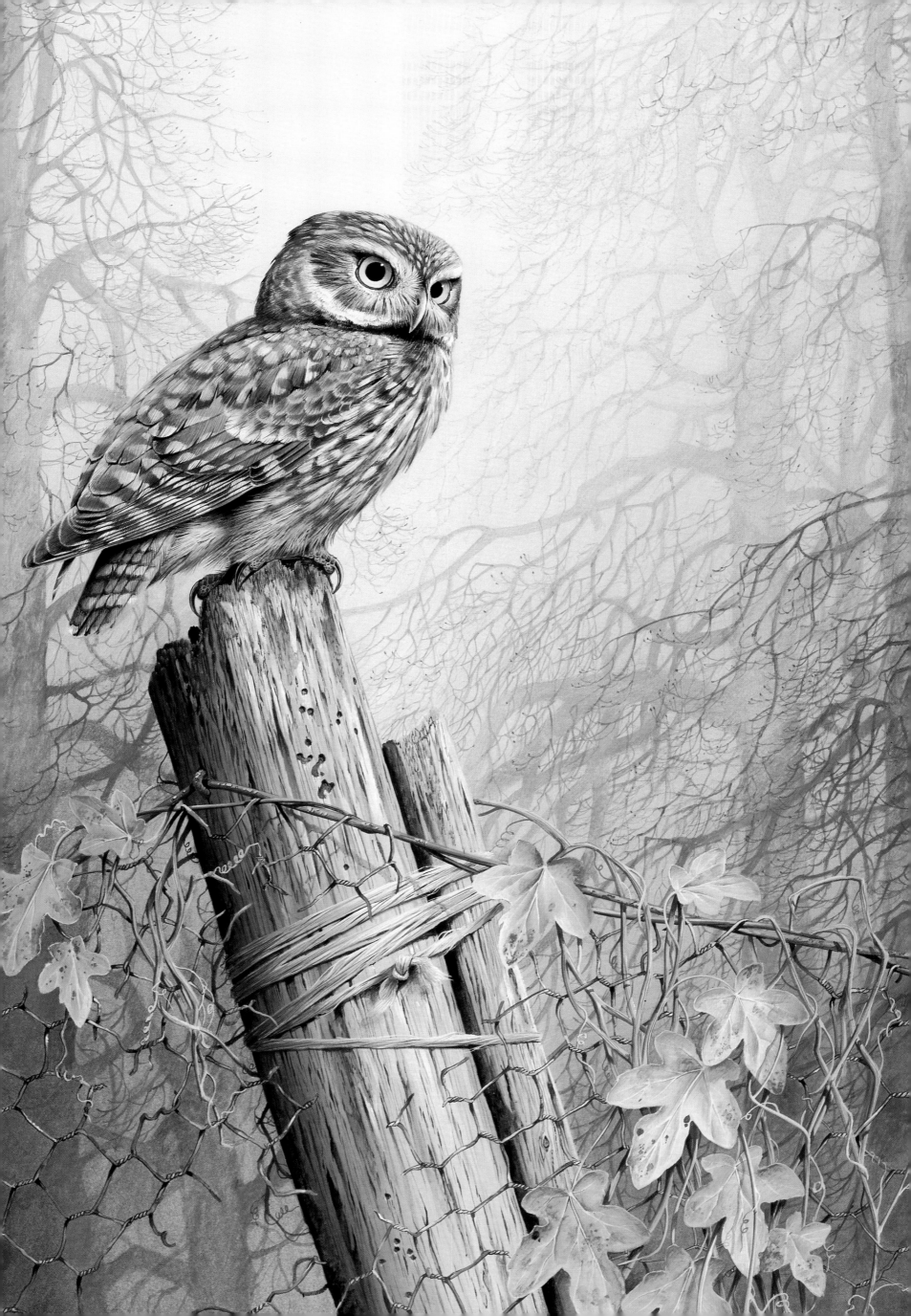

Long-Eared Owl

Names are given to birds and animals for many different reasons. The title that we give to a species may have been derived from its appearance, its habitat or simply from the sound it makes. It is quite obvious why this particular owl is known as the 'Long-Eared'; one glance at the bird's silhouette and the most prominent features are the vertical ear tufts. I have deliberately used the word tufts in this context because that is all they are, despite the fact that the name suggests that they may be directly related to the bird's hearing apparatus.

The true ears are actually hidden behind the large facial discs that surround the bird's eyes. As with all owls the highly-developed ears are located asymmetrically in order that the sounds reach one ear at a slightly different angle from the other. This enables the bird to pinpoint with incredible accuracy the location of the slightest sound. On some species these vertical ear slits are huge, almost the length of the owl's head.

Long-Eared Owls require a combination of acute eyesight and hearing even more than most species, as they are truly nocturnal. Unless disturbed they are rarely seen during daylight, preferring to roost in some well-secluded woodland, usually coniferous, until nightfall.

Voles are a main ingredient in the Long-Eared Owl's diet but other small mammals are also taken, along with the occasional small bird. The population and breeding success of the Long-Eared Owl is affected by the fluctuation in the number of voles available. Rather like lemmings, voles undergo drastic increases and declines in population, sometimes over quite a small area, and this important food item has a direct bearing on the number of young owls raised in a particular season.

Old crow's nests or similar are utilised by the Long-Eared Owl and a single clutch of anything between three and six eggs is laid during late March and early April. The young birds are fledged and leave the nest after about twenty-three or twenty-six days.

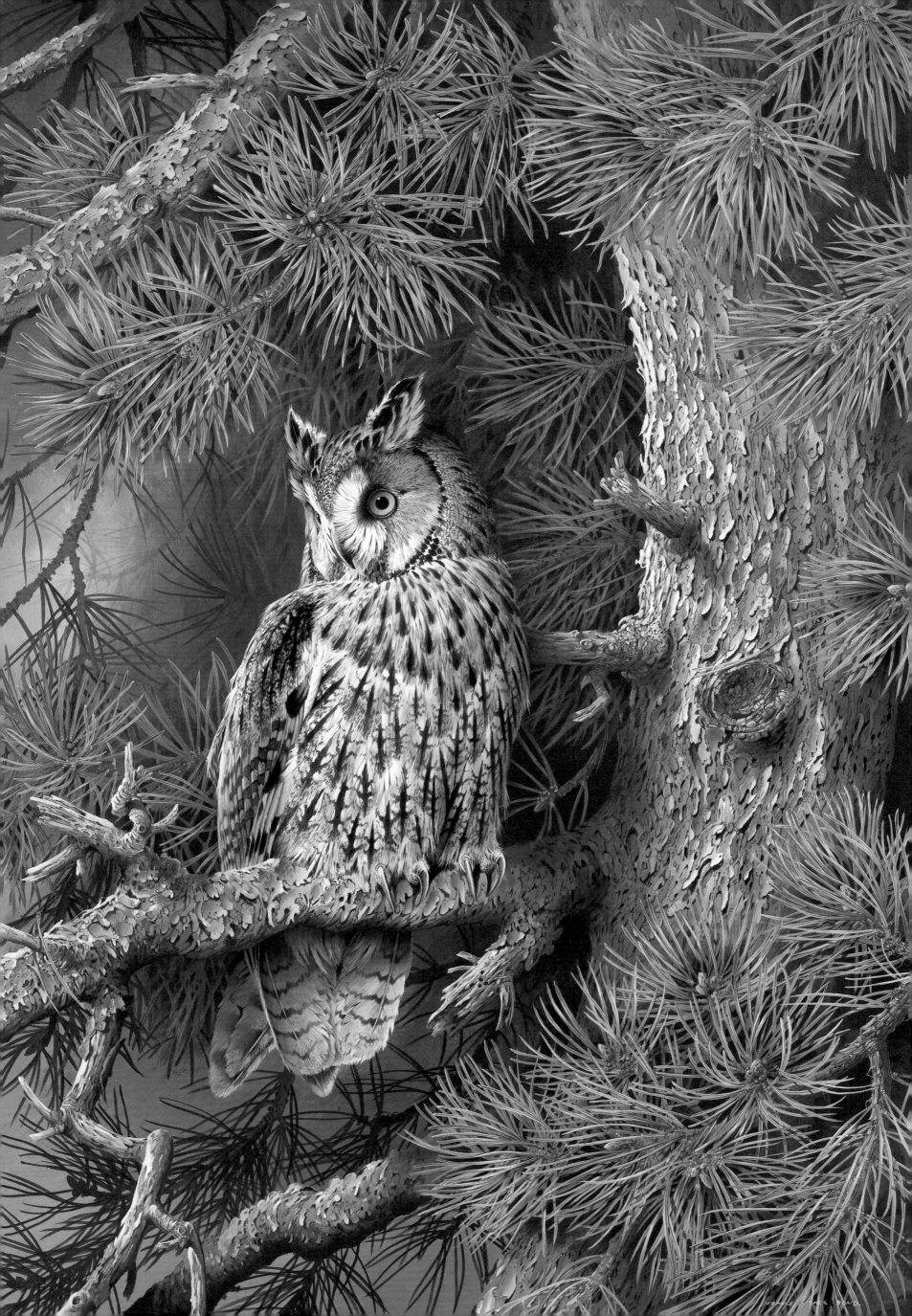

Barn Owl

I often watch a Barn Owl hunting over the long grass, drifting and turning through the trees of my meadow. Dusk is the usual time for these nocturnal predators to emerge from their daylight sleeping quarters and the partly derelict old barn that I have included in my painting is a typical roosting place.

Sadly the illustration opposite depicts a scene which is becoming increasingly rare. Barn Owls are on the decline, and so also are the old and accessible farm buildings in which the species prefers to nest. Hollow trees are just as suitable for nesting, but the loss of much woodland and many hedgerows during the last twenty years has affected the stability of this bird as a breeding species. However, all is not gloom and despondency. The Barn Owl breeding schemes show that they will reproduce quite readily in captivity, and with the introduction of purpose-made nest boxes and suitably designed modern buildings, it is possible to re-establish the bird in areas where it is now no longer found.

The Barn Owl is beneficial to man since its main food items consist of members of the rodent family, in particular, rats, mice and voles, supplemented by moths, beetles and the occasional small bird.

Presumably the bird I watch with such pleasure is searching in my meadow for mice and voles. It looks for all the world like a large silent white moth drifting ghost-like over the tall grass.

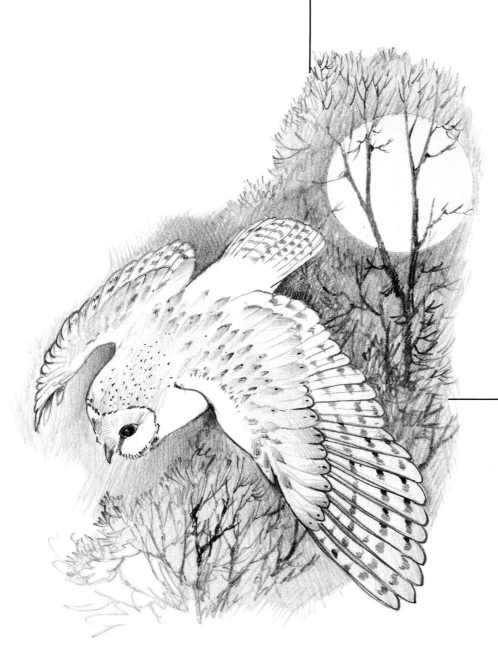

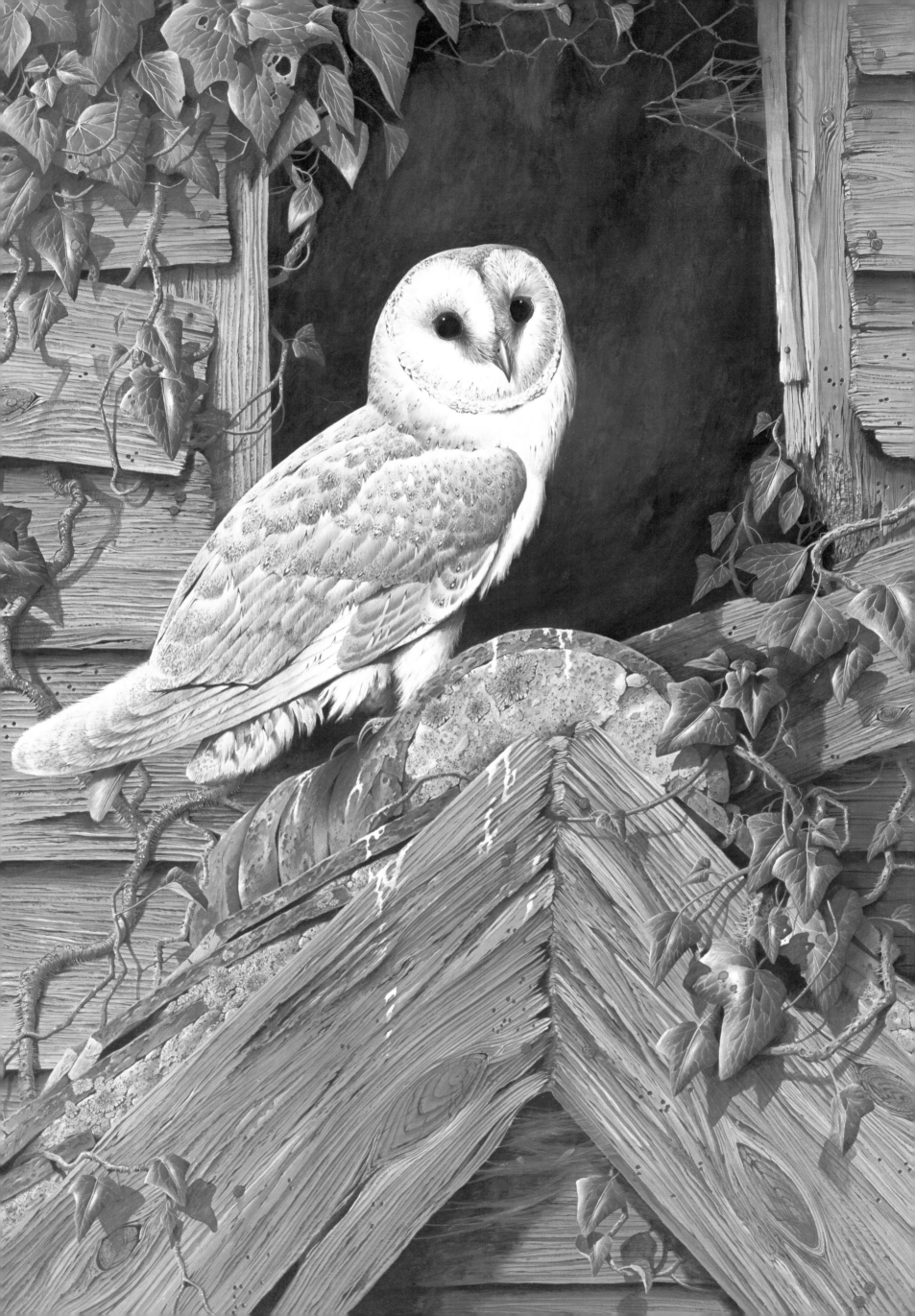

Tawny Owl

The Tawny Owl is a successful bird and probably the most wide-spread owl throughout Europe, north-west Africa and even the Himalayan areas of Burma and China. It is, however, absent from the Americas. Adaptability is one of the keys of the Tawny Owl's success. It is fairly unspecialised in its feeding habits and will tolerate a wide range of environments, including that of man.

In common with other owls the Tawny varies considerably in colour from one bird to another; the specimen skins in my collection are all different. With the exception of the Barn Owl, most owls seem to possess a drab and uninteresting plumage, but close inspection will reveal a myriad of shades and patterns that are quite beautiful. Some of these patterns, particularly on the back and the head, are so finely detailed that owls take longer to paint than most birds. Many of these patterns are disruptive in layout so that individual feathers are hard to separate visually. It is not surprising that in poorly lit woodland these birds are very difficult to see.

The Tawny Owl is illustrated here in a setting of oak trees, for the reason that the slight contrast between the green bark and the bird's plumage is a colour combination that I find pleasing. Oak woods, of course, are the richest woodland of all and offer the Tawny Owl good pickings in the form of voles, shrews, woodmice and large moths. This species will exist on a diet supplemented by small birds if mammals are scarce; I vividly recall a pair of Tawny Owls who regularly removed roosting sparrows from the thatch on the cottage opposite my bungalow where I used to live. In Britain Tawny Owls can be found in a wide variety of habitats from rural woodlands, large gardens and city parks. In more open countryside, with fewer trees, they are less common.

Holes in trees, nest boxes and farm buildings are preferred nest sites. Apparently there are even records of ground-nesting Tawny Owls, but this is most unusual. One brood of two to four chicks is raised during March and April.

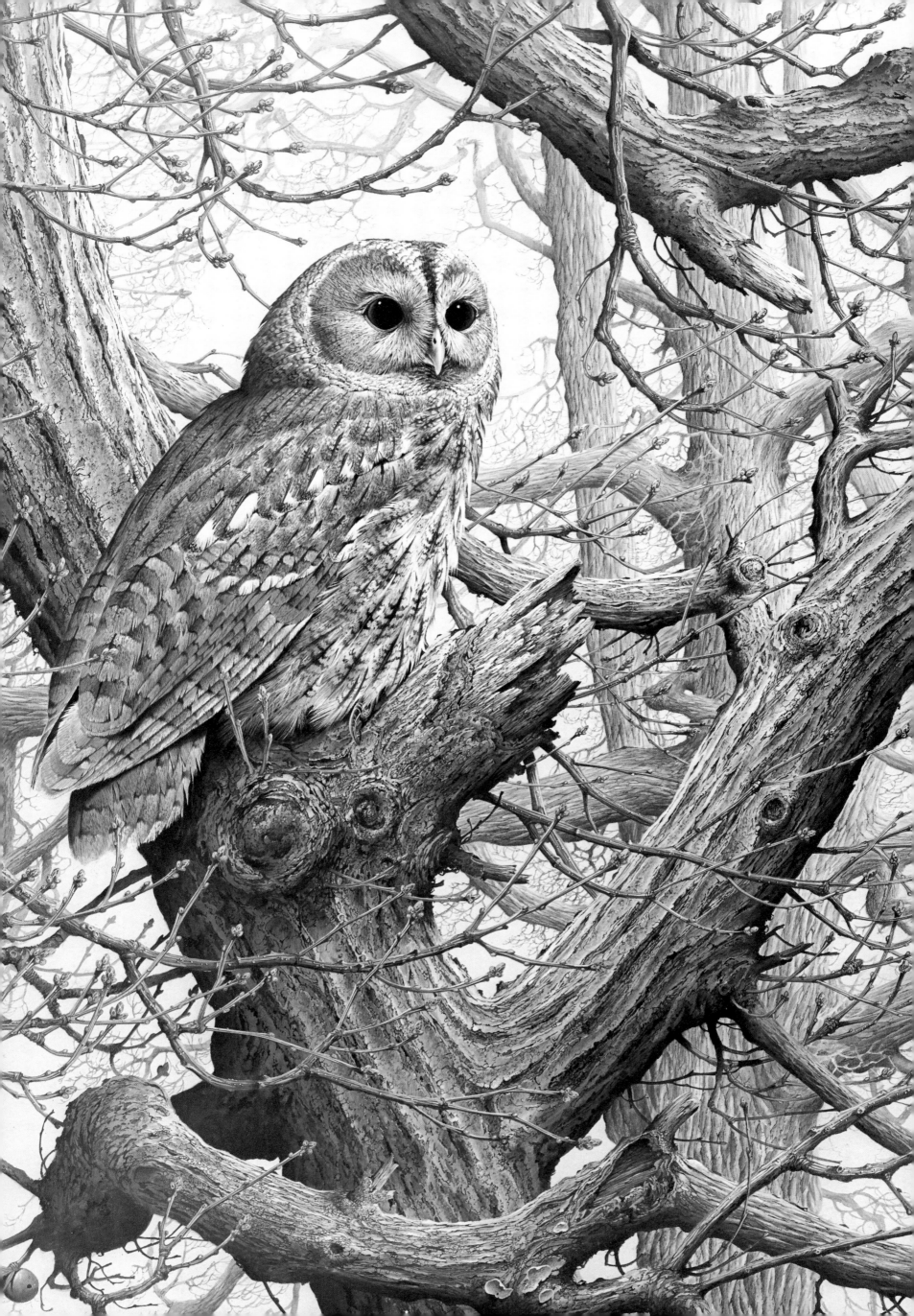

Pied Wagtail

I have yet to see a Pied Wagtail that did not look as though it was running behind schedule! When these streamlined little birds are chasing insects around on my lawn they are a picture of constant nervous activity, leaping several inches up in the air every few minutes to snatch at a passing fly, landing and then darting off in another direction to grab something else. Insects are the staple food of this bird and presumably such a high protein diet is necessary for a species that never seems to stand still.

Wagtails are generally to be found near water. The Pied Wagtail, however, seems to be less dependent on rivers and streams than its close relations, the Grey and Yellow Wagtails. Favourite feeding areas include such diverse locations as lawns, playing fields, sewerage farms, aerodromes and large flat roofs. The habit of pursuing insects across relatively wide open spaces makes the Pied Wagtail more conspicuous than the other two family members. This resident species will take advantage of a variety of man-made constructions in which to build its nest, and the range of holes, cracks and cavities that are utilised is almost as varied as that used by the Robin. During a good season a pair will rear up to three broods, but two is considered normal.

The bird illustrated is a male, in full breeding plumage, almost jet black and pure white with just a hint of brown in the tail. The whole painting has been executed in colours that are generally low key and range predominantly through the umbers and greens. However, by using the reflective qualities of water, I have indicated a blue sky. Adding this bright blue in the immediate foreground has two effects upon the overall image; firstly, it creates a sense of space and light in a painting which has no horizon or visible background and secondly, the colours help reduce the overall contrast of the bird against the dark background. It also adds another tactile element in the form of water.

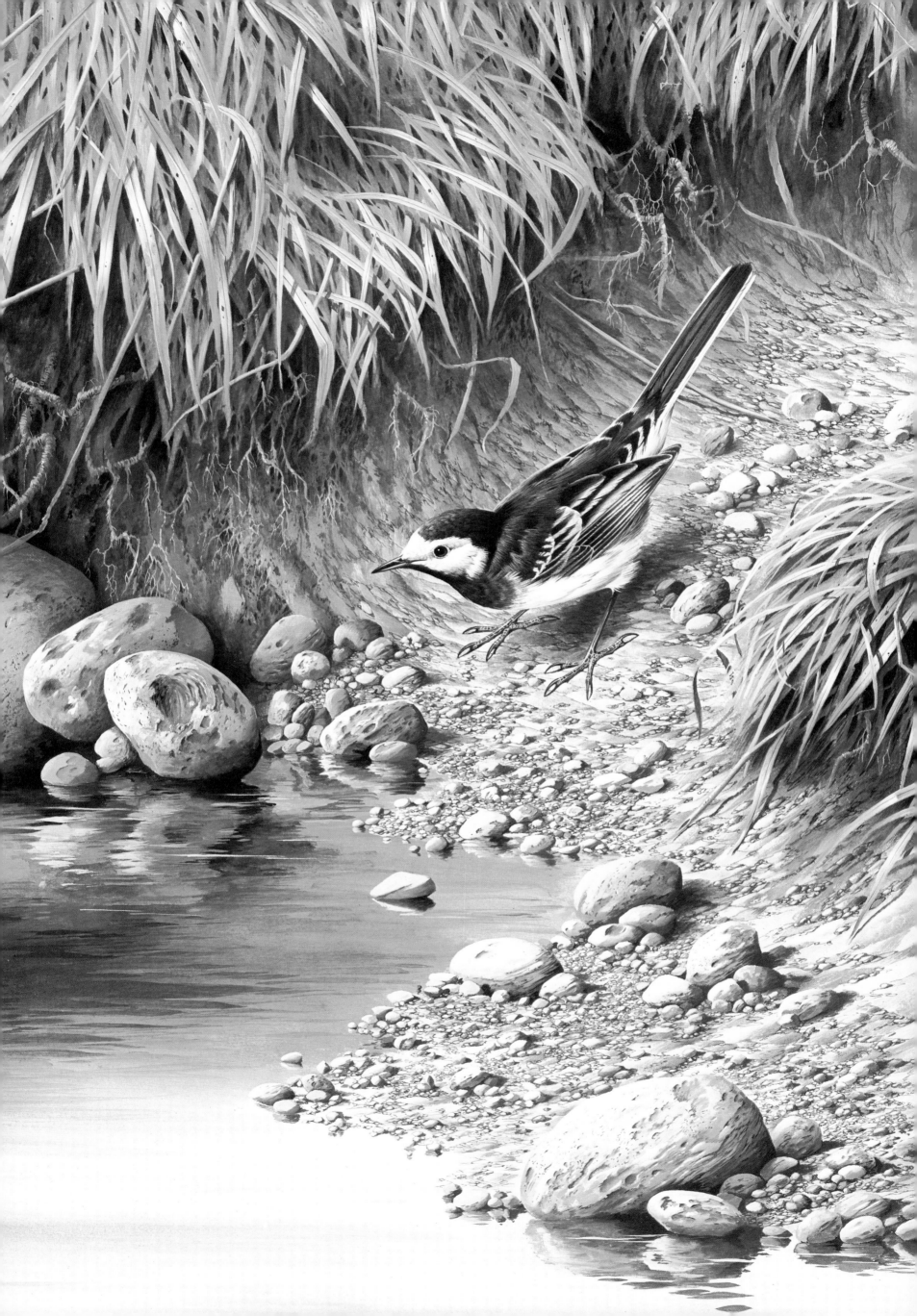

Grey Wagtail

This is the largest of the three wagtails that are on the British list, but only by about an inch and most of that is tail. When painting the Grey Wagtail the most obvious feature from the artist's point of view is the bright yellow underparts, ranging from pale lemon through chrome to almost orange in some places. The bird's name actually refers to the colour on the back and head of the species, reference not being made to the yellow plumage presumably because it would cause confusion with its close relation, the Yellow Wagtail.

Fast-flowing streams of the uplands and moorlands are this bird's original habitat, and it is most common in the hilly and mountainous districts of the country. The bird is somewhat scarce in south-eastern England, but reports indicate there may be a slight increase of resident birds in this area.

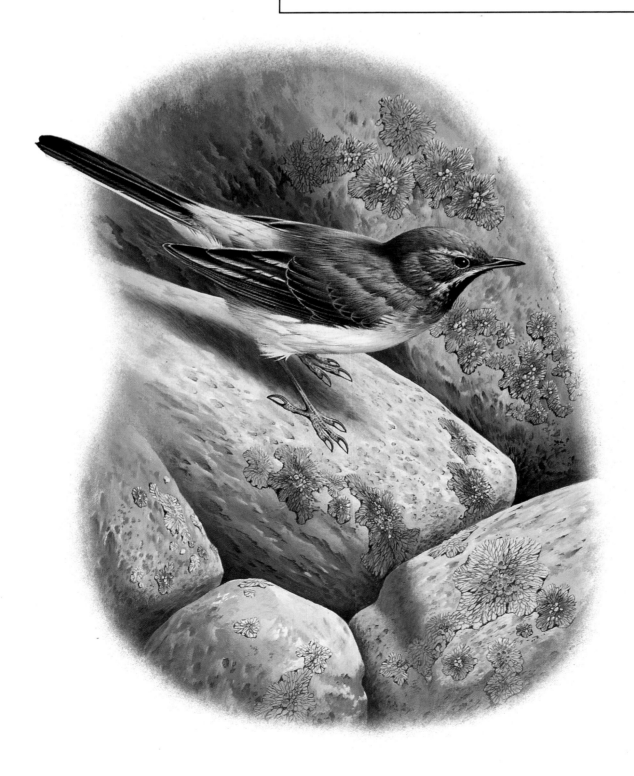

Yellow Wagtail

Because of the almost delicate and fragile appearance of this beautiful little bird I thought that the setting of this particular study should include some equally fine and graceful shapes. The grass stalks and leaves proved ideal, for, besides emphasising the slim and streamlined stature of the Yellow Wagtail, they also add a very strong directional component within the overall composition and contribute to the liveliness of the painting.

This, the smallest of the three wagtails on the United Kingdom list, is entirely migratory and will over-winter in Africa and southern Europe. The bird illustrated here is the British type. There are several colour variants of the Yellow Wagtail throughout its range and in some parts of Eurasia the species *Montacilla flava flava* (grey- or blue-headed) replaces our own yellow-headed type.

In common with other members of the wagtail family the bird is attracted to water and its associated vegetation. However, provided that water is nearby, the bird will frequent meadowland and rough pasture.

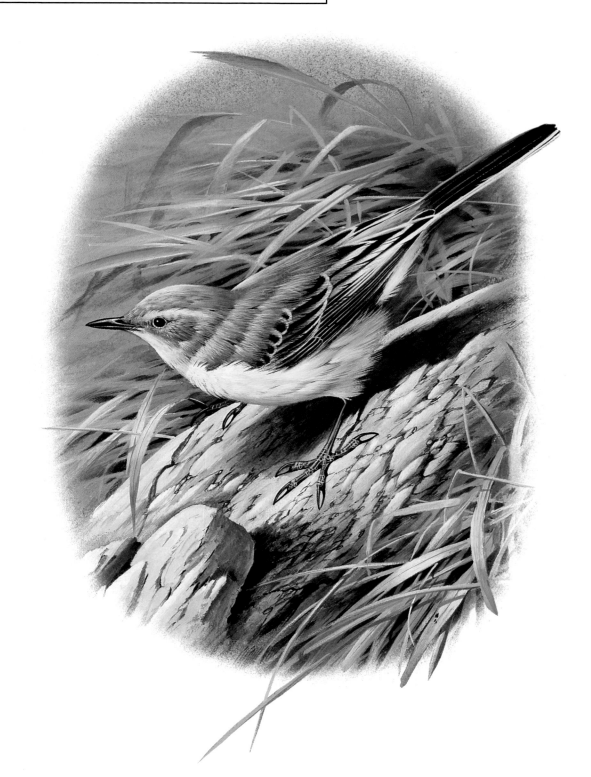

Bearded Reedling

There is a degree of confusion at present as to whether the Bearded Reedling should be called the Bearded Reedling or the Bearded Tit. Older reference books will place this attractive little bird in the titmouse section. However, ornithologists now feel that the species is more closely related to the African babblers than our own titmice. Our other resident long-tailed titmouse (the Long-Tailed Tit) is also under scrutiny since like the Bearded Reedling it builds a self-supporting nest whilst our other titmice are all hole-nesters. Serious ornithologists will agree that this is sufficient reason for the doubt but I am sure that most people will continue to refer to both these species as titmice for some time to come.

The Bearded Reedling is distributed sporadically throughout Europe and the British breeding population is widely scattered and small, the main concentrations being located in the secret reed beds of the East Anglian fenland and coastal marshes. Breeding requirements dictate that the species is restricted in range, particularly so in the United Kingdom, and the total resident population of this country is estimated at approximately 500 pairs. Prolonged severe weather and extreme cold can have a serious effect on the bird and a breeding population can crash or disperse as a direct result of a poor winter.

Fortunately the species has the advantage of being able to raise more than one brood in a single season, two broods and even occasionally three of up to seven young will be raised from late April onwards. So if all goes well and favourable springs and summers prevail between the occasional severe winters, then the bird can build up its numbers to a reasonable level in a comparatively short time.

No visible background is revealed in the painting; the effect that this brings about is almost claustrophobic, but this in turn focuses attention on the birds and their nest-building activities. It also reinforces a feeling of secrecy and offers us a glimpse of what is really a hidden world of inaccessible marshland.

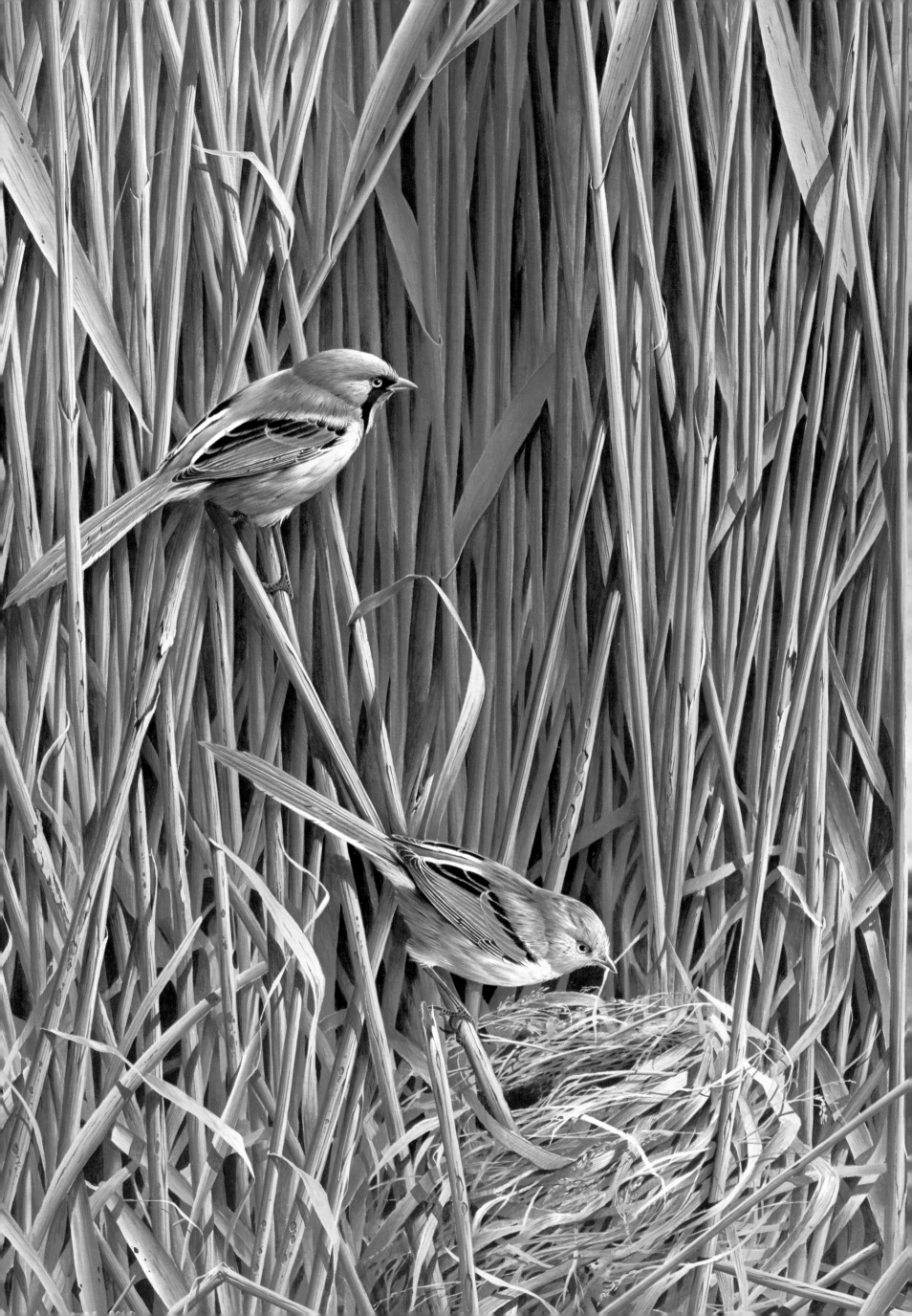

Kingfisher

There can be few birds that are so well known as the Kingfisher, and yet as a species has probably been seen in the flesh by so few people. Kingfishers feature regularly on calendars, greeting cards and such like, and the species has even lent its name to commerce with many shops and businesses using its name.

In common with several other birds in the British Isles the Kingfisher is the only representative of its family or genus, and this alone probably accounts for its ease of identification. The other identifiable factor must of course be the bird's incredible colouring. Basically the bird's plumage is a blue and green mixture on the back, wings and head, with a combination of orange and white elsewhere. The Kingfisher is actually quite a tiny bird, not much larger than a sparrow, but the species anatomy, in particular the large head and beak, gives a false impression of size when illustrated in photographs.

Mortality amongst small birds is always high during the winter and in very severe cold spells the Kingfisher suffers more than most. The first and most obvious problem for a bird dependent on an aquatic food source, is that still water will freeze over and probably remain frozen for several weeks. Added to this, of course, is the shortage of food. A lot of small fish and water insects retire to the bottoms of ponds and lakes for the winter. In very severe conditions a few birds may move to estuaries and salt-water areas, but the movement is generally small and sporadic.

When it comes to painting the bird the artist is presented with a problem. Running down the centre of the Kingfisher's back and tail is a line of feathers that are impossible to represent in paint. Their vivid blue is incandescent in nature and as the bird moves, or as the light changes, so does this colour, varying from one brilliant hue to the next. The effect is caused by the scattering of the light rays through a transparent pigment in the bird's feathers, the reflected light altering from blue to green with every slight movement of the bird. This effect is also visible on certain wing feathers of many ducks. It is referred to scientifically as the Tyndall effect. All the artist can do is represent one of the range of reflected colours in as near a 'kingfisher blue' as the palette allows.

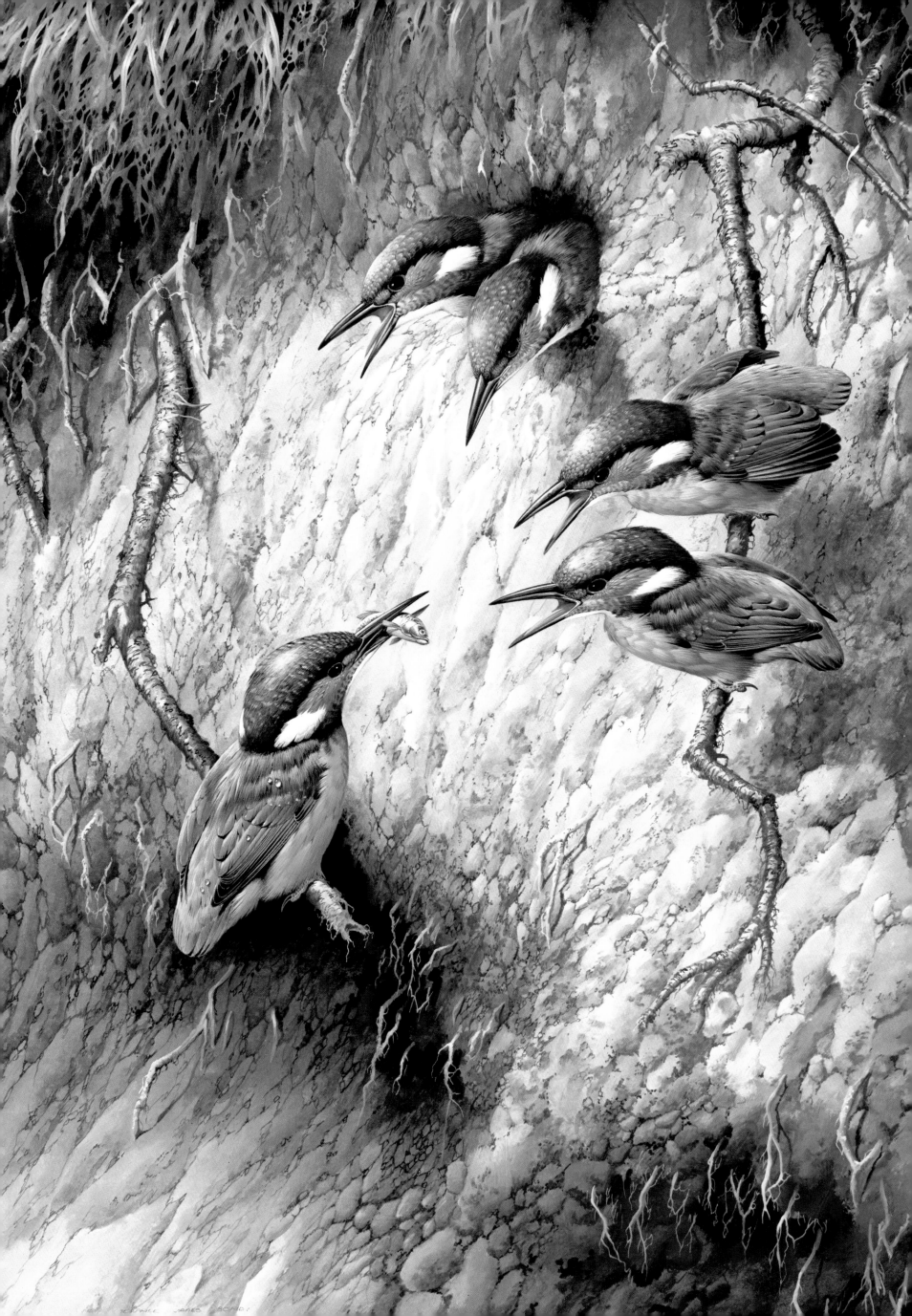

Oystercatcher

Black and white birds are excellent for the bird artist to paint. The two colours are at opposite ends of the palette and will invariably contrast well with most background tints. The red that seems to be present on a large number of pied birds can be a problem occasionally, but in the case of the painting opposite it blended rather well with the grey stones and pebbles. In common with a lot of strikingly coloured birds the real beauty of the Oystercatcher's plumage is not noticeable whilst the bird is stationary, but in flight the transformation is remarkable. It is sometimes difficult to correlate the patterns of a moving bird with the same species at rest, and many of the other coastal waders require considerable study before correct identification can be assured.

Despite the feeding habits intimated by the bird's name, the Oystercatcher in fact does not eat a great many oysters (if any) and its main source of food is other molluscs, such as mussels, cockles and limpets. The long and powerful beak is used as a probe and large numbers of worms, insect larvae and small invertebrates are removed from the mud and sand.

The species is fairly wide-ranging and can be found around most European coastlines and as far south as the African Cape. The bird is represented in Australia by the Pied Oystercatcher whose appearance is superficially very close to the European bird.

One brood is raised consisting of between two and four eggs laid in a shallow nest or scrape and usually lined with seaweed, small pebbles and bits of shells.

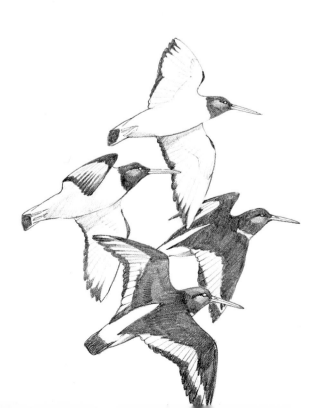

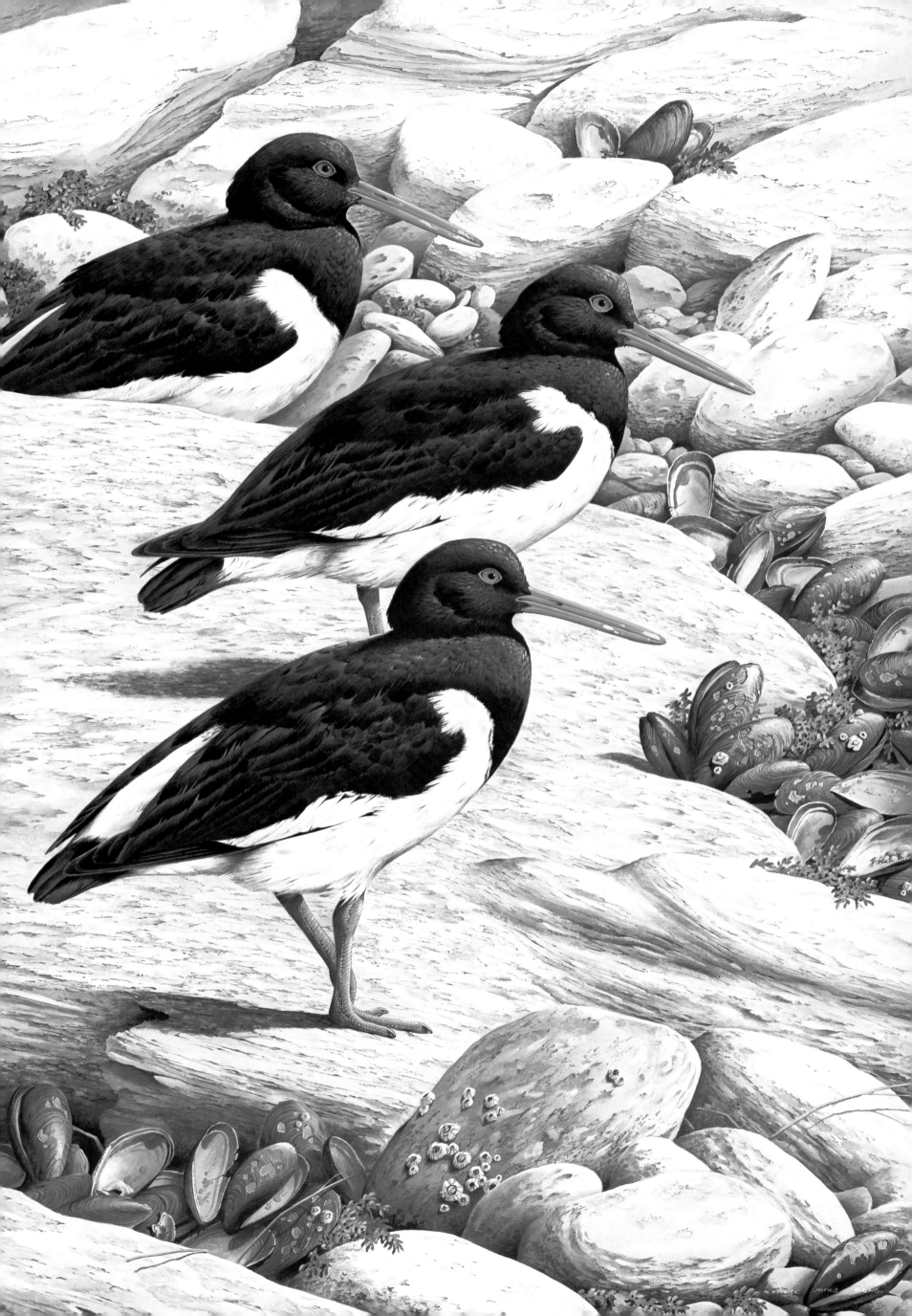

Common Tern

Common Terns are remarkable long-distance migrants and the birds that arrive during the summer to breed around the British coastline may have travelled from as far as southern Africa and other sub-tropical regions. In fact there is even a record of a British ringed bird being recovered in north western Australia! In keeping with this international status, Common Terns are also found as a breeding species on coastlines from mid-Canada down through the Americas.

During the breeding months the birds congregate in large numbers referred to as colonies and in these noisy and busy concentrations, each pair will raise from between two and four young in a single brood.

This painting is quite simple and consists of only three elements, the bird, the stones and a piece of rope, and the success of the painting rests entirely on the positioning of the bird and the rope. Stones are a subject that I have always found interesting and very satisfying to paint. Every one is different, yet using the geometric shape of the large stones, a force and direction can be set up in the composition which balances the otherwise over-powering effect of such an intricate background.

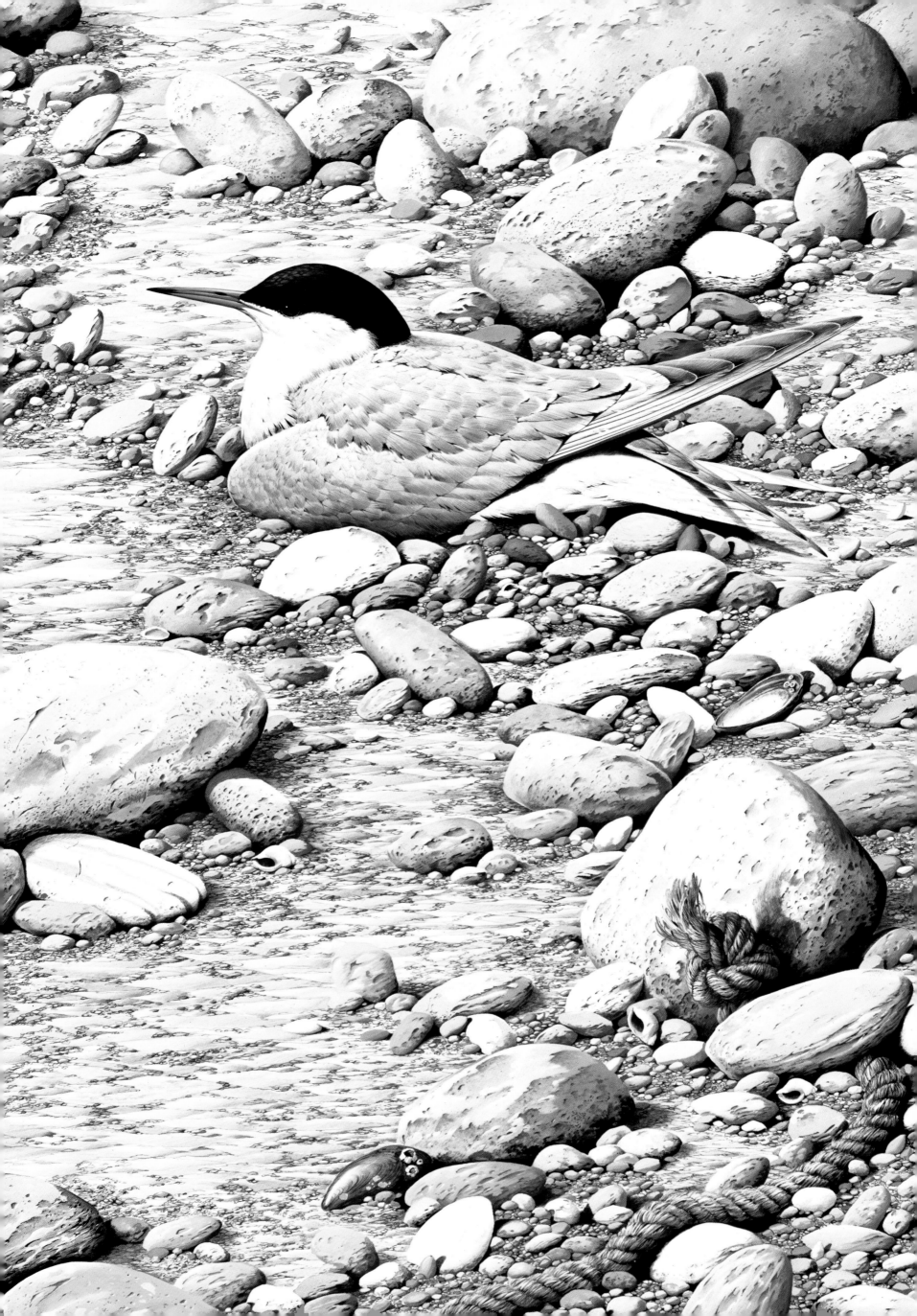

Puffins

To some people the physical appearance of the Puffin is most peculiar; large coloured bill, short dumpy legs and a generally awkward disposition. The bird's popularity is, however, unquestioned and many regard the bird with great affection. Their behaviour is usually endearing and at times downright comical, and they can also on occasions become very tame, a characteristic which unfortunately has led to the downfall of many species in the past. Fortunately in these more enlightened times modern man has come to recognise tameness as a sign of trust shown by a particular animal and will respect the species accordingly.

The brilliantly coloured beak of the Puffin is assumed only during the breeding season and the rest of the year this remarkable tool is smaller and somewhat drab in appearance. The bird's beak is employed in the excavation of a nest hole, or the enlarging and adapting of an existing opening or crack. A preferred choice would seem to be a vacant rabbit burrow. My four Puffins are illustrated in a typical coastal cliff-top environment, with steeply sloping verges usually covered with a degree of grass and vegetation. In order to add more impact to the four birds I have resisted the temptation to show a horizon or background in the painting, preferring to use the combination of the Puffin's dramatic plumage to create a strong composition.

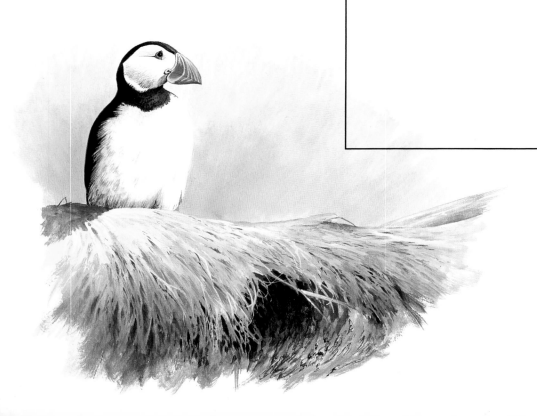

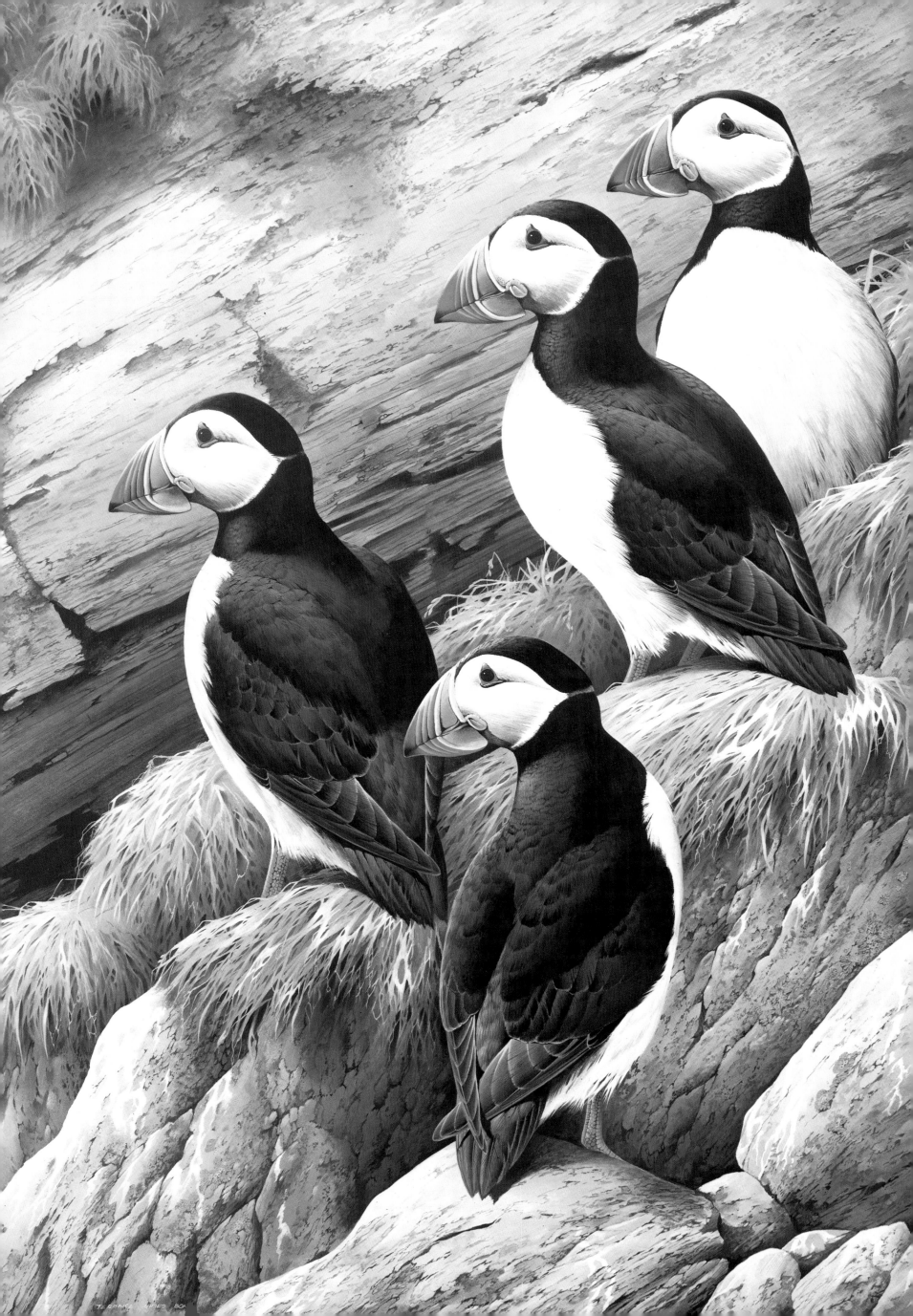

Teal

Wildfowl (ducks and geese) are one of those particular groups of birds that seem to attract a slightly different type of bird watcher and bird lover from the norm. During my painting career I have been asked to illustrate several species of duck and geese by various clients and with few exceptions the people concerned seem to possess a degree of enthusiasm with regard to wildfowl that far exceeds their interest in the other bird families.

Without doubt they are very beautiful birds, and practically all the males (drakes) of the species are handsomely marked with a variety of colours and feather patterns. The Teal is no exception. This is a small duck, one of Europe's smallest in fact, and is renowned for its consummate flying skill and aerobatic manoeuvres, should the bird be alarmed or approached suddenly, it is capable of spectacular high-speed vertical take off!

During the breeding season the bird is associated with shallow inland water, rushy moorland, upland streams and pools, in fact anywhere that dense cover adjacent to water is available. The single clutch of between six and eight eggs is laid around late April and early May, and incubation is generally for a period of twenty-two days or so. In common with most waterfowl the young are perfectly capable of leading an independent aquatic life as soon as they are hatched, but they will stay in family groups until early autumn.

When one of these small birds is held in the hand, or examined at close quarters, a phenomenon common to many ducks becomes apparent. The plumage, which seems at a distance to be a uniform grey or fawn colour, is in fact the effect given by a complex and intricate feather pattern, consisting of hundreds of tiny lines running across the feathers. A not dissimilar feature is possessed by the plumage of many of the owls. These patterns are sometimes purposely disruptive and serve to help break up the outline of various parts of the bird's anatomy, particularly in poor light. In the case of many of the ducks it disguises successfully the demarcation lines between the wings and tail and the rest of the body. The general outline of the birds is also softened and blurred making them much more difficult to see. It also makes them difficult to paint!

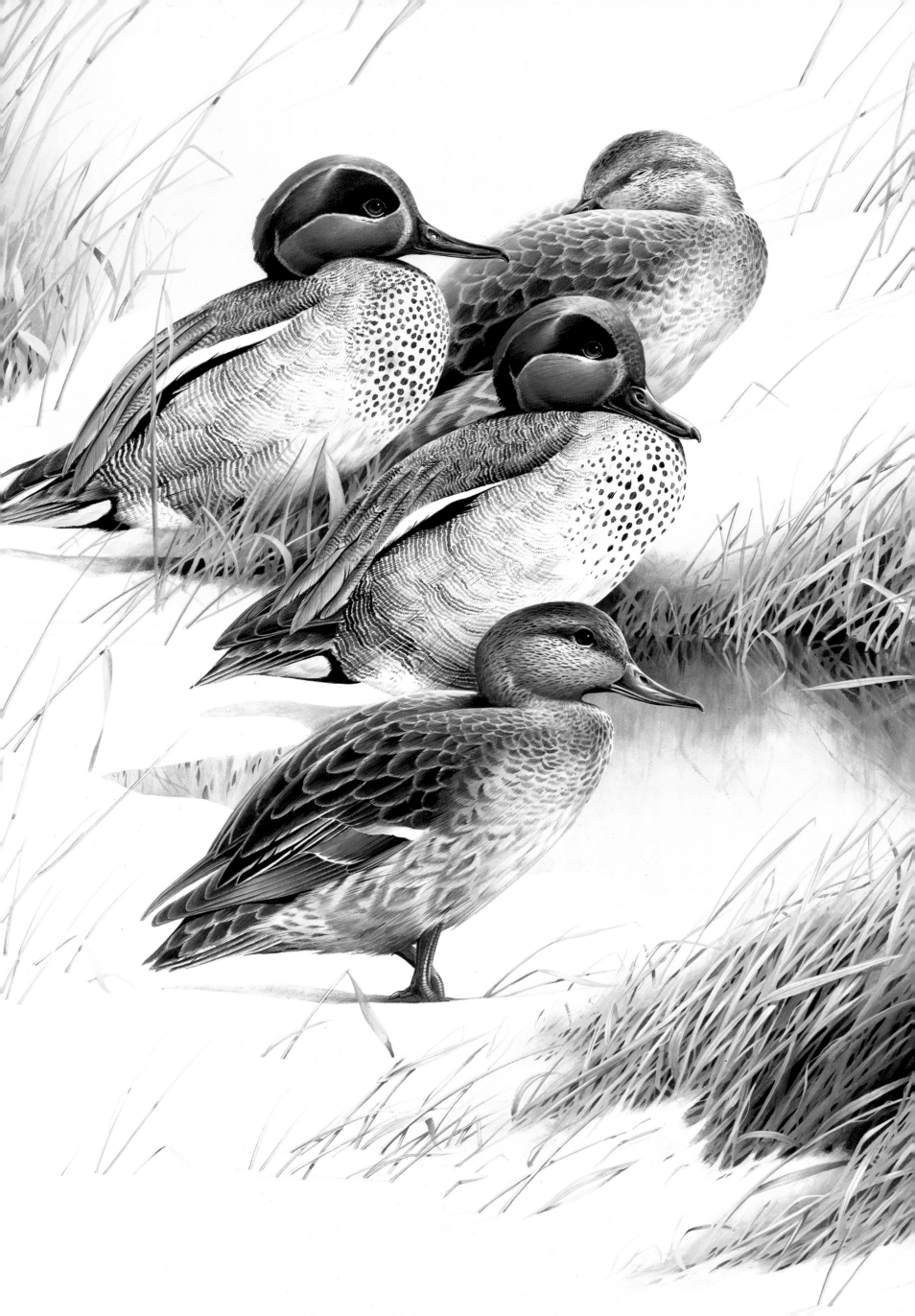

Acknowledgements

The author would like to thank Mr Simon Girling for his help and support over the last three years, the team at Lutterworth Press for guiding him through the complexities of the publishing process, to all those who have been kind enough to lend pictures from their collections for inclusion in this book and to his wife, Jill, for her help with the preparation of material and for her support, without which his career as an artist would never have started and which has sustained him throughout it.

The publishers would like to thank Bemrose -Calendars and Diaries for providing material for the reproduction of illustrations marked * from the Royal Society for the Protection of Birds calendar.

The publishers and author would like to thank the owners of the following paintings: Robin (p. 5) Mr P. Jarvis; Greenfinch (p. 7) Mr K. J. Bird; Goldfinch (p. 7), Five House Sparrows (p. 19)*, Coal Titmouse (p. 25), Redwings on Hawthorn Berries (p. 43)*, Barn Owl (p. 60)*, Pied Wagtail by Stream (p. 73)*, Three Oystercatchers (p. 81)*, Common Tern in Stones (p. 83)* Private Collection; Brambling (p. 7) Mr E. Knowles; Bullfinch, Pair (p. 13)*, Long-Tailed Titmice (p. 23)*, Hobby on Scots Pine (p. 57)* Mr C. Knowles; Yellowhammer (p. 7) Miss D. Jary; Blackbird (p. 9), Swallow Family (p. 41)*, Bearded Reedlings with Nest (p. 77)* Mrs. W. Phillips; Songthrush (p. 11) Mrs M. Martin; Seven Chaffinches (p. 15)*, House Sparrows with Apples (p. 17) Mr G. K. Parker; Wren on Nestbox (p. 21)*, Four Puffins (p. 85)*, Bemrose Corporation; Willow Titmouse (p. 24) Mr R. Cubitt; Lesser Spotted Woodpecker (p. 27)* Mr F. Gallagher; Green Woodpecker (p. 31) Nuthatch, Pair, in Willow (p. 35)* Mr J. J. McGee; Four Sparrows (p. 33)* Mr B. Cowling; Pair of Blue Jay (p. 37) Nature Scene, Canada; Sedge Warbler, Study (p. 39), Reed Warbler, Study (p. 39), Kestrel in Ivy (p. 59)*, American Kestrel (p. 61) Mr W. Dalziel, C.B.E.; Little Owl (p. 65) Mr M. W. Dalziel; Willow Warbler, Study (p. 39) Mr R. J. Dyer; Fieldfare in Snow (p. 45)* Mr S. Girling; Cock Pheasant (p. 47)*, Red-Legged Partridges on Logs (p. 49)* Major C. W. Jones; Peregrine Falcon (p. 55)* Artist Collection; Tawny Owl (p. 71)* Mr D. Stanton; Grey Wagtail, Study (p. 74), Yellow Wagtail (p. 75) Mr E. Sexton; Kingfisher family (p. 79)* Mr K. Rush; Teal in Snow (p. 87)* Mr R. Groves.

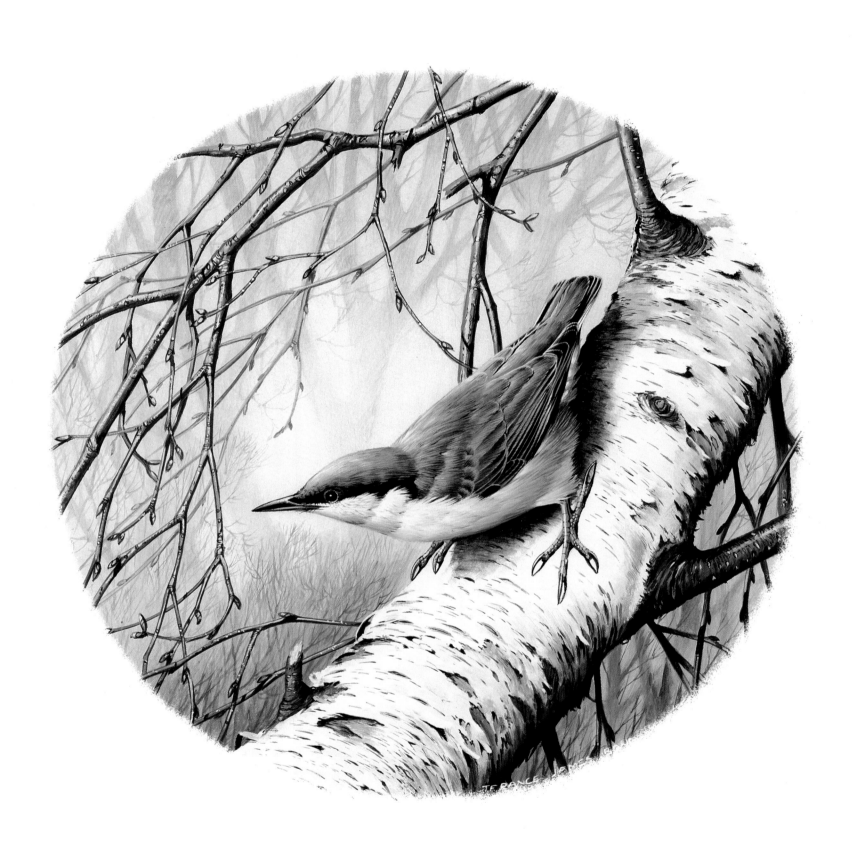